An Archaeology of Architecture

An Archaeology

of Architecture

of Architecture

PHOTOWRITING THE BUILT ENVIRONMENT

Dennis Tedlock

Foreword by Arthur Sze

UNIVERSITY OF NEW MEXICO PRESS | ALBUQUERQUE

The following photographs are published with the permission of the persons named: "An Old Paris Brasserie," Sylvia Paret and Keith McNally at Balthazar Restaurant in New York City; "Lower on the Driver's Side" and "Waiting for Candles," Patricia Trujillo Oviedo of Centinela Ranch in Chimayó, New Mexico; "Before and After Katrina," Donna Allen at Maple Street Bookshop in New Orleans; "Juan de Oñate Rides Again," John Sherrill Houser and Troy Pillow; "Giving Privacy to Guests," Mei-mei Berssenbrugge and Richard Tuttle of New York City and El Rito, New Mexico.

This book was published with assistance from the University at Buffalo Foundation.
Design and production by Karen Mazur

Library of Congress Cataloging-in-Publication Data
Tedlock, Dennis, 1939–
 An archaeology of architecture : photowriting the built environment / Dennis Tedlock ; foreword by Arthur Sze.
 pages cm
 Includes bibliographical references.
 ISBN 978-0-8263-5305-4 (cloth : alk. paper) — ISBN 978-0-8263-5306-1 (electronic)
 1. Architectural photography. 2. Architecture and anthropology. 3. Photography in archaeology. I. Title.
 TR659.T43 2013
 779'.99301—dc23
 2012031808

Contents

Contents, ctd.

Foreword

I FIRST ENCOUNTERED DENNIS TEDLOCK's groundbreaking work with his Zuni narratives, *Finding the Center*. In those pieces, he paid particular attention to silences, to pitch, and to the various parameters of performance. As I followed Dennis's work in Mayan literature, from his remarkable translation of the Popol Vuh to his more recent *2000 Years of Mayan Literature*, I've been continually moved and impressed by his acute understanding of the nuances and layers of implication in these works.

An Archaeology of Architecture, Dennis Tedlock's book of photographs and text, continues this signature power of attention and precision of language. With the text on one side and the image on the other, Dennis presents a series of sixty-seven double-page spreads that shift location freely, from New York City to Guatemala, from Amsterdam to New Mexico. Text and image coexist in fertile tension, in charged conversation. Although the text unfolds from the image, you can read the words, form an expectation, and then be startled by what you see in the image; or you can look at the image, form an expectation, and then be startled by what you read. As image and text mutually inform, enlarge, complicate, hone, and deepen one another, you will find that the gaps between image and text and between each pairing give your imagination space to contemplate, discern, and discover. In this luminous and marvelous book, you can sharpen your attention, deepen your understanding, and enrich your experience of the world.

—ARTHUR SZE

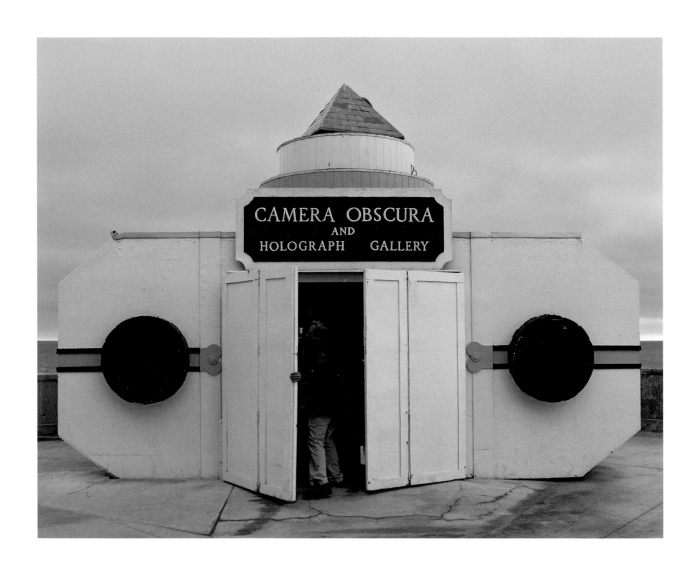

Prologue

"WHO WOULD BELIEVE that such a small space could contain the image of all the universe!" So said Leonardo, writing about the camera obscura, the "dark room" of his own day. On the wall before him was an upside-down image of the world outside the room, projected by a small aperture in the wall behind him. Arab and Chinese authors had described such rooms four centuries earlier. By the eighteenth century, Europeans had transformed the room into a portable box with a lens in front and a pane of ground glass in back. In 1839–1841, when the images projected by the lens were frozen in time by Daguerre and Talbot, the camera obscura became the ancestor of the camera that took this picture of a camera obscura designed to look like a camera. Between the two knobs for advancing the film, the viewfinder takes the form of a doorway. Beyond the blue wall is the "gallery," a dark room with a table in the middle, ready for a séance. The specter enters through an aperture whose rim is visible on the right side of the pyramid on top of the camera's lens shaft, then strikes a mirror set at an angle and passes downward through two lenses that project a round image onto the table. The pyramid rotates for six minutes, giving visitors a "holograph," a continuous, real-time image of Seal Rocks, the open sea, Ocean Beach, San Francisco, and Seal Rocks again. But the image is faint, like a remembered dream.

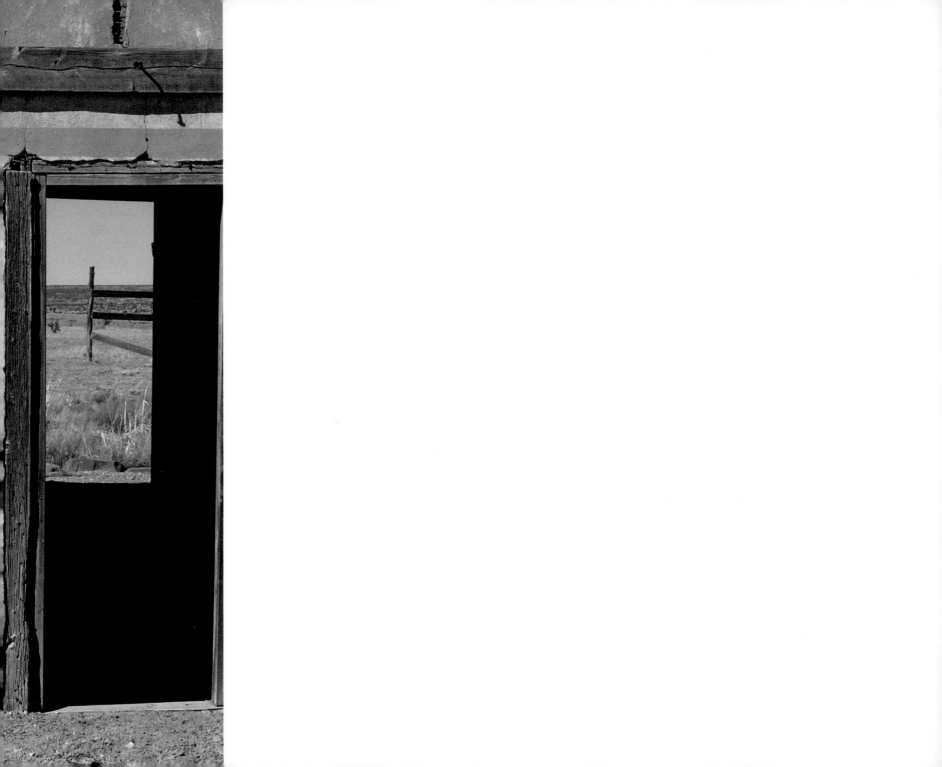

Introduction

ARCHITECTURE BEGINS WITH a plan. Sometimes it takes shape in drawings and models, sometimes it moves directly from mental images into the hands of the builders. But when architecture takes the shape of an actual building that changes through time, the plan recedes into the past. Photography works the other way around. It starts from buildings that are already there, complete with evidence of past changes, and fits them into a plan of its own, a rectangle enclosing a composition. The composition of a photograph may be quite different from what the architect envisioned, but the shape of the picture serves as a reminder of the architectural origin of photography. In the nineteenth century, when the camera obscura or "dark room" was transformed into a portable box with a lens in front and a light-sensitive surface in back, the rectangularity of the room's back wall took precedence over the circularity of the image projected through the aperture in the front wall.

During my long career as an anthropologist, I have always carried a camera wherever I went. At first I followed the path of an archaeologist, but after a few seasons in the silent world of ruins, I became an ethnographer, seeking conversations with the members of living cultures, making sound recordings, and continuing to take pictures. But to this day, whenever I look around at the worlds humans build for themselves, I see archaeology in the making. Everywhere, there are signs of past events that led to the present state of things and signs that suggest the direction of future events. Architecture—whether new, old, or in ruins—is continuously altered by human actions or natural forces. Photographs bring these alterations to an illusory standstill in the present, serving to document a world that existed at the time when the photographer was in the field. But the evidence of past and ongoing changes is still there, waiting to be read with an archaeological eye.

Meanwhile, the photographs themselves recede into the past, serving as images of a world contemporary with the viewer only briefly before they take on the look of historical documents. In the metropolitan world, even buildings that are relatively recent and in good condition are succeeded by newer buildings that make them look out of date. Nothing ages faster than the products of modernity.

Contemporary architects are in the habit of emphasizing the creation of space when they theorize their work. Their drawings typically consist of thin lines laid out on surfaces that are largely left blank, as if to avoid even the illusion of materiality.[1] Construction, on the other hand, involves a complementary relationship between materials and spaces. Architects specify the materials to be used and may include sketchy indications of textures in their drawings. But it is the builders who transform the materials into the floors, walls, and ceilings necessary for the creation of spaces, making changes in the plans as needed. A photograph returns a building to a virtual state, but unless the image is digitally modified to make it resemble a line drawing, it cannot show images of spaces without images of materials. When a building is ready for occupancy, an architectural firm may commission a professional architectural photographer to create images that give no hint of the wear and tear, repairs, and alterations that will come soon enough. What was sketchy in the drawings now becomes a material realization of the architect's intentions, frozen in time and not all that different from a scale model.

Builders depart from the plans on their way to the finished building, and when the occupants take over, they set about making their own changes. They put up signs and take them down, trim plants or let them go wild, move furniture in and out, seal old windows and doors and open up new ones, install new wiring and plumbing, and add new layers of paint and plaster, one on top of the other. All these activities leave traces that are visible to the camera. Outsiders add posters and graffiti, and a muralist may transform a flat wall into a scene filled with virtual objects and spaces that have nothing to do with architecture as such. Material objects that played no role in the plan of a building or the composition of a mural may stand between the building and the camera.

Weather leaves marks on a building that only constant repairs can disguise, and the ground beneath it may sink or slide. Always, whether a building is old or new, there are continuous changes in light, shadow, hue, and texture, some of them quick enough to deprive the photographer of an intended image. A reflection may change the proportions of a building, turn it upside down, or dissolve it into filaments of light.

When a building is abandoned, windows are broken, roofs cave in or blow away, wood rots, metal rusts, plaster crumbles, and masonry collapses. Sun, wind, water, soil, and trash enter everywhere, and plants grow where no one planted them. A building in ruins may be subject to repairs intended to stop it from falling any further into ruin, and someone may attempt to run its history backward to some imagined moment in the past. With or without such attention, ruins retain traces of the unnatural geometries human builders are good at producing: long straight lines, rectangles, perfect circles, rows and stacks of same-shaped solids.

Anthropology has a long tradition of dividing the study of buildings between two subfields, assigning ruins to archaeology and structures currently in use to ethnology.[2] These two domains seem clearly defined when the gap between occupation and abandonment is a matter of multiple centuries, but in fact, an occupied building bears marks of the same processes that produce archaeological remains. It may even harbor a ruin beneath it. A ruin may be reoccupied by an archaeological excavation or a succession of excavations, each of which leaves its own marks. A ruin elevated to the status of a monument may be stabilized and opened to the public, bringing on another kind of reoccupation.

Specialists of various kinds have moved into some of the spaces that separate traditional ethnology and archaeology, among them ethnohistorians, ethnoarchaeologists, historical archaeologists, cultural resource managers, and ethnographers of tourism. Whether photographs are utilized by these specialists or by those who see themselves as writers of proper ethnology or archaeology, their usual role in publications is to support an argument or narrative whose primary vehicle is a text.[3] But photographs always reveal more than what the text says about them. This is partly because photographs that capture what is already there in front of the camera

(rather than something staged for the camera) necessarily include elements of chance, no matter how tightly they may be composed. They may include objects; relationships between objects; and qualities of light, shadow, texture, and color that are extraneous to the meaning of a closely argued or plotted text. More than that, as records of appearances, photographs have what the art critic John Berger calls an "oracular" quality: "Like oracles they go beyond, they insinuate further than the discreet phenomena they present, and yet their insinuations are rarely sufficient to make any more comprehensive reading indisputable."[4]

Roland Barthes described photographs as "an analogical reproduction of reality" in which there is no "discontinuous element that could be called a *sign*: there is literally no equivalent of a word or letter in a photograph."[5] Because of this lack, he denied the possibility that photographs could constitute a "language." By this, he meant language in the narrow sense of a closed system of discrete signs. Leaving aside the problem of photographs in which written words appear, as they frequently do in the built world, his formulation glosses over the existence of continuous elements in actual language use, along with the existence of discontinuous elements in actual photographs.[6] Speakers may change their volume and pitch, adding acoustic depths, shallows, and continuities to what would otherwise be a staccato succession of consonants and vowels, delivered in a monotone. Photographs that show smooth gradations from light to dark or from one color to another may also display abrupt changes that mark the boundaries between objects. Barthes himself noticed that many photographs contain what he called a *punctum*, a particular detail that jumps out from what surrounds it.[7]

If there were no discontinuities in a photograph, we would be left with very little to say in response to it. To define language solely in terms of its discontinuities is to treat it as if no one ever *spoke* it, and to define photographs in terms of a lack of discontinuities is to treat them as if no one ever *looked* at them.

Whether the photographer is looking at a scene just before taking a picture or a viewer is looking at the resultant photograph, there is never a moment at which the eyes produce raw perceptions, waiting for the brain to differentiate the visual field. What Rudolf Arnheim called

"visual thinking" begins in the sensory organs, whose transmissions to the cerebral cortex already include contrasts in color, brightness, shape, and distance.[8] This is the kind of thinking photographers rely on when seeking the right composition for a picture—wordless thinking, but with clear discontinuities.

For Susan Sontag, the fact that a photograph represents a moment in time, dissociated from what went on around it, limits the possibilities of interpretation. She writes, "The truths that can be rendered have a very narrow relation to the needs of understanding."[9] Roland Barthes takes a similar position, arguing that the interpretation of photographs is limited because they immobilize time, reproducing what has "occurred only once."[10] But a photograph always reveals more than the mere coexistence of the phenomena that happened to be visible when the shutter opened. The various parts of the image that passed through the aperture together had different starting points and followed different paths to get there.[11] They are like the disparate lights that reach a photograph taken through a telescope at night, in the sense that their apparent simultaneity diverts attention from the depth and complexity of their histories.

PHOTOWRITING

Walter Benjamin, writing a half century before Sontag and Barthes, arrived at a radical view of the relationship between writing and photography. He quoted Lázló Moholy-Nagy as having said that "it is not the person who is ignorant of writing but the one who is ignorant of photography . . . who will be the illiterate of the future." But then he posed this question: "Mustn't the photographer who is unable to read his own pictures be no less deemed an illiterate?"[12] He saw photography as a form of inscription, and he urged writers to take up cameras.

To write toward the historical understanding of a photograph means looking beyond the moment at which it was taken, reaching into the multiplicity of its pasts. At the near end, this could mean going back to an earlier hour on the same day; at the far end, it could mean going back hundreds or even millions of years. In the process, the writer gives the photograph what Benjamin called an "afterlife," a life that follows the moment at which the camera brought

previous life to an apparent standstill.[13] Photographers focused on the task of producing images that claim the status of fine art are in the habit of leaving the task of understanding to others, creating works that are, in effect, perfectly preserved corpses, ready for viewing in silence.

By its very name, photography (also called heliography in its early days) is already a kind of writing, just as writing is a kind of graphic art. This has never been truer than it is now. Photographers and writers both apply their hands to keyboards, and as they work toward publication, they try out their compositions on the printers attached to their computers. Unless an image is scanned from film or a text is transcribed or scanned from a handwritten source, the "originals" are digital files that cannot be viewed until they are read with the aid of a computer. Once they are retrieved, there is no limit to the number of identical copies that can be printed.

No longer is the photographer separated from the writer by the possession of a darkroom equipped with enlargers, trays full of chemicals, drying racks, and a sink. The way is now open for what I call *photowriting*, the processing of photographs and words by the same person running software on the same equipment. Among the possibilities are montages like the ones I offer here, in which I intend the pictures and texts to query, complement, and enlarge one another.

So far, my project has been confined to photographs in which I filled the frame largely or entirely with images of buildings. As Sam Abell has observed, "Photography's power to suggest life—past, present, and future—is often realized in images of the built world. . . . Each speaks directly of its own history and indirectly of a larger cultural history."[14] Such images are replete with the echoes, traces, and results of speaking, writing, and other human acts that have taken place within that world, giving the photowriter numerous ways of entering a discourse that was already under way when the photograph was taken. In contrast, images of what was a natural scene (until the photographer composed it) may evoke a prior discourse that was already at the distance of a nonparticipating observer, objectifying the nonhuman world.

This is not a project in documentary photography. I have not gone out on assignment, looking for images that take their places in a preconceived narrative held together by the classical unities of action, time, and place. Nor have I tied the pictures to the accompanying texts by means of

figure numbers and callouts. Instead, my texts and pictures proceed in pairs, with each member of a pair in the same visual field as the other, just as they were when I did the writing. The relationship between one pair and the next is more like a change of stanzas in a long poem than a change of episodes in a narrative unified by a plot.[15] In a given pair, the written side may have the character of a story, but I have tried to let the story unfold from the picture side and from that particular picture. Threads of subject matter tie some pairs to others—for example, cameras, films, filmmaking, and theaters recur several times—but this is not the result of a preconceived project. Rather, the threads emerged in the process of putting the book together.

To seek an interactive relationship between words and images is to work outside the system that has long governed the canonization of works in the verbal and visual arts in the Western world. The ideal text should not need any illustrations, and the ideal picture should not need any text beyond a short caption, set in small type as if to minimize the embarrassment of having any text at all. When I try to think of books in which the text and photographs have both been canonized, only one comes to mind: *Let Us Now Praise Famous Men*, which first appeared in 1941 and remains in print to this day.[16] The author of the text was the journalist and screenwriter James Agee, and the photographer was Walker Evans. Both the text and photographs concern the lives of white sharecroppers in the South during the Great Depression, but all the photographs are gathered in a portfolio at the front of the book. There are no captions, and the text makes no direct reference to any particular photograph. In this way, the photographer and writer maintain the purity of their respective artistic identities.

Let Us Now Praise Famous Men was preceded, in 1939, by its opposite: *An American Exodus: A Record of Human Erosion*, by photographer Dorothea Lange and economist Paul S. Taylor. In their foreword, they state that "this is neither a book of photographs nor an illustrated book, in the traditional sense. . . . Our work is a product of cooperation in every respect from the form of the whole to the least detail of arrangement or phrase."[17] They follow the story of cotton production and its human costs—for both blacks and whites—from the Deep South across to California. The photographs, captions, and text are closely fitted, spread by spread, and even the

photograph on the dust cover carries a caption. *An American Exodus* was remaindered soon after it appeared and was not reissued until 2000, in a facsimile edition published in France.[18] Its canonization, in traditional terms, would require driving a wedge between Lange and Taylor.

It is tempting to blame the deep split between image and text on the alphabet, whose letters long ago lost their connection to images. But when lettering was done by hand, books were filled with images, sometimes drawn and painted by the same hand that drew the letters. It was only after the arrival of letterpress printing that books consisting of nothing but alphabetic text became common.[19] Print technology brought with it a wider separation between texts and images, which were prepared for the press using different methods and materials. The split reached the point where the two kinds of work were (and still are) done by separate specialists, working for separate firms.[20] Academia replicates the split, assigning literary scholars and art historians to separate departments.

During the first half of the twentieth century, avant-garde painters and poets who were contemporaries of Benjamin worked toward a reunification of the verbal and visual arts, inserting texts in their pictures and using typography to create images and diagrams.[21] I have taken a different approach here, allowing text and picture to remain inside their separate rectangular fields. There is a precedent for montages of this kind in the printed emblem books of the sixteenth and seventeenth centuries.[22] In the simplest arrangement, each page carried a separate emblem. At the top was a *motto*, a title often set entirely in capitals, and below that was a *pictura*, printed from a woodcut or engraving. Under that was a *subscriptio*, a text occupying approximately the same amount of space as the image. Alternatively, the picture was placed on the left side of a double-page spread and the text on the right, with the title repeated at the top of both pages. Sometimes the text ran over onto another page. Together, the picture and text constituted the emblem, whose meaning emerged from the combination of looking and reading.

More recent forerunners of my picture-and-text montages fill the pages of the first commercially published book devoted to photographs, which appeared in 1844–1846. The title was *The Pencil of Nature*, and the author was none other than William Henry Fox Talbot, the inventor

of paper-based photography.[23] He paired each full-page plate with a typeset text running one to three pages long, beginning on a facing page that carried a title. In writing the texts for his architectural photographs, he provided information as to the season and time of day when the picture was taken, the orientation of the camera (and thus the viewer), the geographical location of the scene, and the identities and histories of the buildings. He also called attention to such details as the weathering of stone and the posting of printed materials on walls. All of these subjects and more come up in the texts I have written for my own photographs.

In formatting my paired texts and images for display in a gallery, I printed each pair on a separate broadside.[24] With the intent of intensifying the relationship between text and image, I departed from the model of the single-page emblem by starting the text above the image and continuing below it. The pairs presented in this book are on facing pages, but I have departed from the model of the double-page emblem by placing the text on the left and the picture on the right, and in confining the title to the text side.

For the photographs and texts, I have aimed at the same high level of readability. In the case of the photographs, this means maintaining the original high level of resolution, the full range of the original light-to-dark scale, and colors as close to the original gamut as the technology of reproduction permits. In the case of the texts, high readability means giving them greater typographic prominence than the captions in photobooks and photography magazines, which are often reduced to the lower limit of legibility. The ink used here is black (not gray), the type size is large enough to be read from a comfortable distance, and the lines have the proper proportion between their width and the distance between them.

Like the author of an emblem book, I hope my reader/viewer will look back and forth across each spread, seeing more in the picture than the words can tell and reading more in the words than the picture can show.

NOTES

1. For a large collection of contemporary architectural drawings, see Francis D. K. Ching, *Architecture: Form, Space, and Order* (New York: John Wiley & Sons, 2007). Drawing instructions given to contemporary architecture students, with repeated emphasis on space, are enumerated in Matthew Frederick, *101 Things I Learned in Architecture School* (Cambridge, MA: MIT Press, 2007). Materials are mentioned in only a handful of the 101 statements in this book. In contrast, Le Corbusier focused on mass, surface, and plan, of which the first two implicate materials (*Towards a New Architecture*, trans. Frederick Etchells [1931; repr., New York: Dover, 1986], 21–64). Vetruvius, writing his ten-book treatise on architecture in the first century BCE, balanced five books on form with five books on building materials and engineering problems, but the latter books have been excluded from the most recent English translation (Thomas Gordon Smith, *Vetruvius on Architecture*, New York: Monacelli Press, 2003, 10).

2. For a recent critique of the archaeology/ ethnology divide by an archaeologist with an interest in contemporary urban ruins, see Shannon Lee Dawdy, "Clockpunk Anthropology and the Ruins of Modernity," *Current Anthropology* 51 (2010): 761–93. She sees signs of an archaeological turn in anthropology in general.

3. For a striking exception to this rule, see Jay Edwards, "Creolization Theory and the Odyssey of the Atlantic Linear Cottage," *etnofoor* 23, no. 2 (2011): 50–83. Edwards equalizes the space occupied by text and images through the use of a double-column format in which one column is filled with figures. His argument is carried as much by the images as by the text.

4. John Berger, "Appearances," in *Another Way of Telling* by John Berger and Jean Mohr (New York: Pantheon, 1982), 119.

5. Roland Barthes, *The Grain of the Voice: Interviews 1962–1980*, trans. Linda Coverdale (New York: Hill and Wang, 1985), 353.

6. For a discussion of the outdoor presence of writing in the contemporary built world, illustrated with photographs by Robert Lawrence, see Johanna Drucker, *Figuring the Word: Essays on Books, Writing, and Visual Poetics* (New York: Granary Books, 1998), 90–99. For a photography book devoted entirely to images in which writing is present, see Lee Friedlander, *Letters from the People* (New York: Distributed Art Publishers, 1993).

7. Roland Barthes, *Camera Lucida: Reflections on Photography*, trans. Richard Howard (New York: Hill and Wang, 1981), 27, 40–60.

8. Rudolf Arnheim, *Visual Thinking* (Berkeley: University of California Press, 1971), chaps. 1–4.

9. Susan Sontag, *On Photography* (New York: Farrar, Straus and Giroux, 1977), 112. It is difficult to say what sort of images she had in mind when she made this assertion. In effect, she created the antithesis of books filled with reproductions of photographs, giving herself the last word, so to speak, by excluding illustrations entirely.

10. The quote from Roland Barthes is from *Camera Lucida*, p. 4; his extended argument concerning the relationship between photographs and time comes at the end of this book, on pp. 87–107.

11. Jacques Derrida criticizes Roland Barthes for adhering to "a chrono-logic of the instant" that "supposes the undecomposable simplicity, beyond all analysis, of a time of the instant" (*Copy, Archive, Signature: A Conversation on Photography*, ed. Gerhard Richter, trans. Jeff Fort [Stanford, CA: Stanford University Press, 2010], 8).

12. Benjamin's quotation of Moholy-Nagy, followed by the question he raised in response, appears in his "Little History of Photography," first published in 1931; see pp. 295–96 in the translation by Edmund Jephcott and Kingsley Shorter in Walter Benjamin, *The Work of Art in the Age of Its Technological Reproducibility and Other Writings on Media*, ed. Michael W. Jennings, Brigid Doherty, and Thomas Y. Levin (Cambridge, MA: Harvard University Press, 2008), 274–98. In the "Little History," Benjamin identifies the author of the quotation only as "somebody," but in an earlier essay he attributed the same words to Moholy-Nagy (*The Work of Art*, 272). In neither case did he cite a published source. What Moholy-Nagy actually said in print is somewhat different: "A knowledge of photography is just as important as a knowledge of the alphabet. The illiterate of the future will be ignorant of the use of camera and pen alike." He uses these words in two different essays: "A New Instrument of Vision," in *Moholy-Nagy*, ed. Richard Kostelanetz (New York: Praeger, 1970), 54 and "Photography in a Flash," 56–57.

13. Walter Benjamin, *The Arcades Project*, trans. Howard Eiland and Kevin McLaughlin (Cambridge, MA: Belknap Press of Harvard University Press, 1999), 460.

14. Sam Abell, *The Life of a Photograph* (Washington, D.C.: National Geographic, 2008), 126.

15. Paul Strand introduced a portfolio of his photographs by stating that they did not constitute "a linear record," but should rather be seen "as a composite whole of interdependencies" (*Sixty Years of Photography* [New York: Aperture, 1976], 173).

16. The publisher of the original 1941 edition of *Let Us Now Praise Famous Men* still has an edition in print, but with sixty-four additional

photographs by Evans that have the effect of shifting attention more toward him (Boston: Houghton Mifflin, 2001). For a critique of this book and three others (including Barthes's *Camera Lucida*) classified as "photographic essays," see W. J. T. Mitchell, *Picture Theory* (Chicago: University of Chicago Press, 1994), chap. 9.

17. Dorothea Lange and Paul S. Taylor, *An American Exodus: A Record of Human Erosion* (New York: Reynal and Hitchcock, 1939), 5–6. Outside of this particular project, Lange always provided captions for her photographs, and she was angered when publishers replaced or omitted them. For examples of her captions, some of them quite lengthy, see Linda Gordon, *Dorothea Lange: A Life Beyond Limits* (New York, W. W. Norton, 2009), 431–34.

18. The facsimile edition of *An American Exodus*, which carries two critical essays, was published in 2000 in Paris by Jean-Michel Place, as part of a series titled *Histoire figurée*.

19. On the relationship between pictures and texts during the Middle Ages, see Meyer Shapiro, *Words, Script, and Pictures: Semiotics of Visual Language* (New York: George Braziller, 1996). For an account of the relationship that runs as far as the use of the printing press, see John Dixon Hunt, "The Fabric and the Dance: Word and Image to 1900," in *Art, Word and Image: 2,000 Years of Visual/Textual Interaction*, ed. John Dixon Hunt, Michael Corris, and David Lomas (London: Reaktion Books, 2010), 34–85.

20. For a full history of the technology of the printed picture, including photo offset and digital printing, see Richard Benson, *The Printed Picture* (New York: Museum of Modern Art, 2008).

21. It was Dadaists, surrealists, and cubists who introduced texts into their works. For text-and-image works by Pablo Picasso, Georges Braque, Stuart Davis, Francis Picabia, Joan Miró, André Breton, Max Ernst, René Magritte, and Man Ray, see David Lomas, "'New in art, they are already soaked in humanity': Word and Image 1900–1945," in ed. Hunt et al., *Art, Word and Image*, 110–77. For Paul Klee, see Jeremy Adler, "Paul Klee as 'Poet-Painter,'" in the same volume, 178–201. On the visual uses of typography, see Drucker, *Figuring the Word*, 110–36.

22. Numerous examples of emblem books are available in facsimile on these and other museum and library websites: rijksmuseum.nl/aria/aria_encyclopedia/00047659?; emblems.let.uu.nl; emblem.libraries.psu.edu/home.htm; lib.virginia.edu/rmds/portfolio/gordon/emblem/; images.library.uiuc.edu/projects/emblems

23. *The Pencil of Nature* was originally published

in London by Longman, Brown, Green and Longmans; it came out in six installments, running from 1844 to 1846. The most recent facsimile and the one with the best versions of the plates was issued in 2011 by KWS Publishers of Chicago and London, under the auspices of the National Media Museum in Bradford, UK.

24. In the spring of 2011, the Meridian Gallery in San Francisco featured an exhibit of fifty-three of these broadsides, titled *An Archaeology of Architecture*.

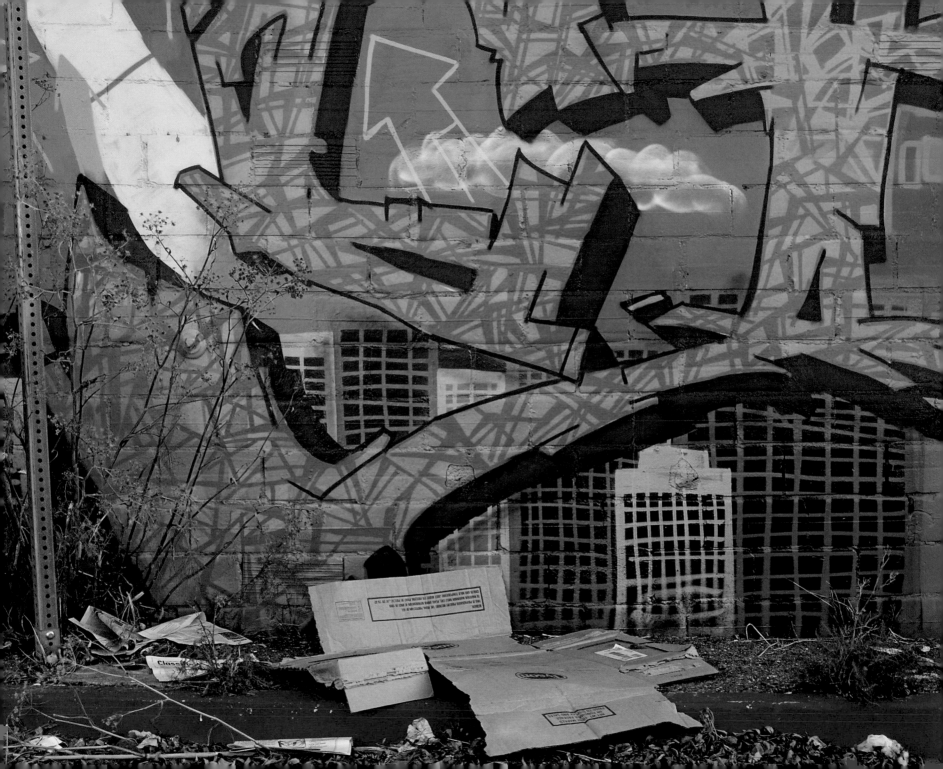

PHOTOWRITING THE BUILT ENVIRONMENT

An Old Paris Brasserie

The reversed lettering of the red EXIT sign tells us we are looking into a mirror, but the words in the window are not reversed, since the mirror has given us the view of a person reading from outside the café in which we find ourselves. At right is a clock whose roman numerals, running counterclockwise, are hard to read through the tarnished silvering of the mirror. The long hand, pointing right, has climbed one minute past IX. On the other side of the clock, the short hand has descended most of the way from I to II. Taking the daylight outside into account, the time is 1:46 p.m., and we can imagine that the people inside, some seated at tables and others at a bar, are eating lunch. From the white shirts of the two standing men at left and the black-and-white attire of the standing woman and bending man at right, we can infer that they all belong to the wait staff. The man facing us at bottom center, holding a camera with both hands, is taking the picture at this very moment. It is May, and seven Mays before this one, the result would have been a picture of a leather wholesaler's warehouse. When the café opened, the reviewer for the *New York Times* observed that "it has the weary, slightly cynical look of an old Paris brasserie." It is named for Balthazar, the magus whose gift was myrrh. We are on Spring Street at the corner of Crosby, in SoHo.

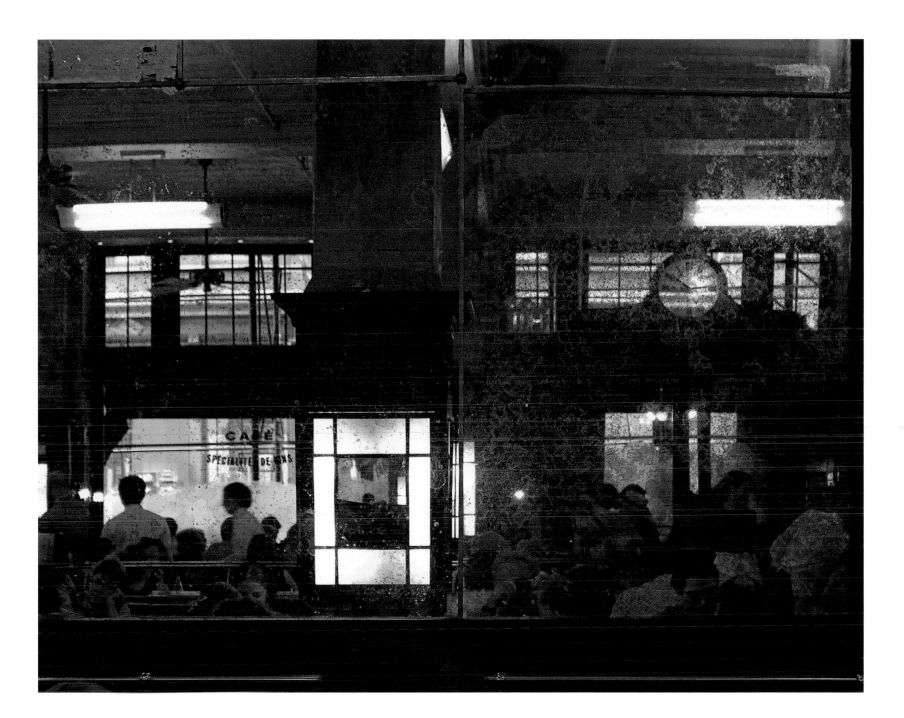

Shiatsu Shampoo and Sushi

Shortly before sunset, the light inside these four places of business becomes brighter than the light outside. The Subway shop is empty but stands ready to swallow its customers, drawing them under its trademark marquee, telling them in neon that the open door is open, and luring them inside with photographs of salads, not sandwiches. In the window above, neon names a nail salon for 47th Street, and this is East 47th Street, not far from the United Nations. Next door to Subway, the more intimate experience offered by Sushi Masa has caught the attention of the couple walking down the street with laptop bags. Standing in place of pictures of food is a star magnolia tree in full bloom, with leaves just beginning to come out. To the right behind the signpost, a greening vine emerges from a wooden planter, reaches up through a trellis, grasps the pole that holds the banner at top center, and climbs clear out of the picture. The door at bottom right leads to Salon Shin, whose square red logo appears above the door and again on the banner. Haircuts and styling are preceded by a shiatsu shampoo and massage. From the sushi and shiatsu side of the picture, the boundary between the two buildings is blurred by the magnolia tree, the vine, and the April breeze that moves the banner.

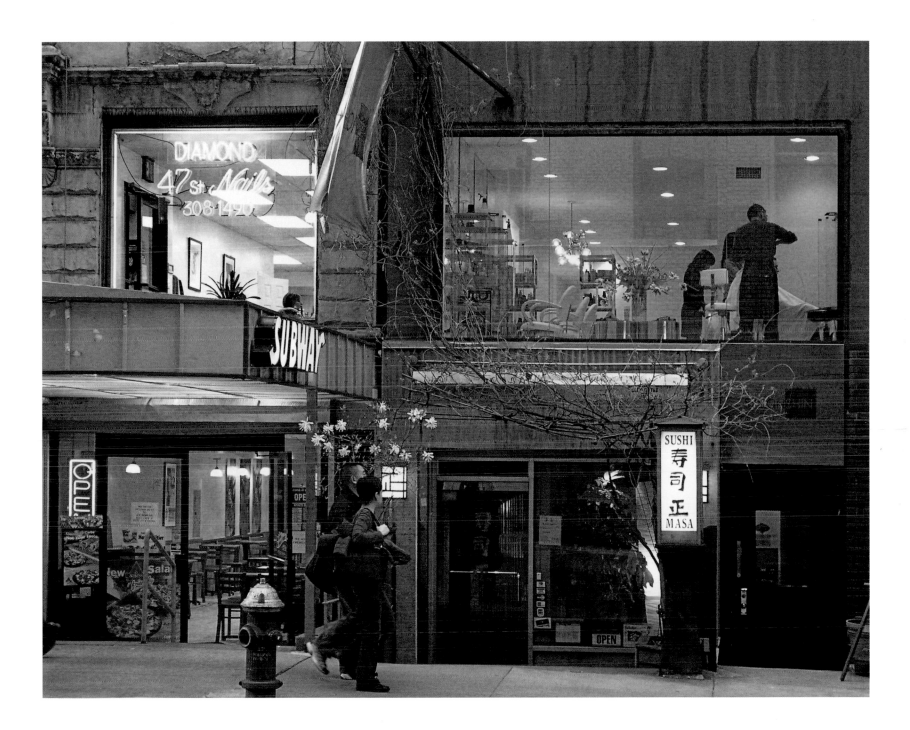

Four Kinds of Writing

The summer sun is still high enough to reach down to the delivery vans on the west side of Stockton Street, between Pacific Avenue and Jackson Street in San Francisco. Before the vans arrived, three scripts accounted for all the writing on display here: traditional Chinese characters (not the simplified characters promoted by the PRC), uppercase Roman letters, and Arabic numerals, all intended to be legible for anyone needing to read them. Between the vans is the entrance to Wing Sing Dim Sum, Cantonese for "Eternal Victory Snacks," an eatery that takes no reservations, accepts no credit cards, makes no deliveries, and has no waiters, no alcohol, no TV, and no Wi-Fi. There are a few tables, but most people come for takeouts. Just $4.00 will buy us rice plus our choice of one of the scores of fried, steamed, or baked items on display in the window to the left of the entrance. A fourth kind of writing comes and goes with the vans, carrying secret messages.

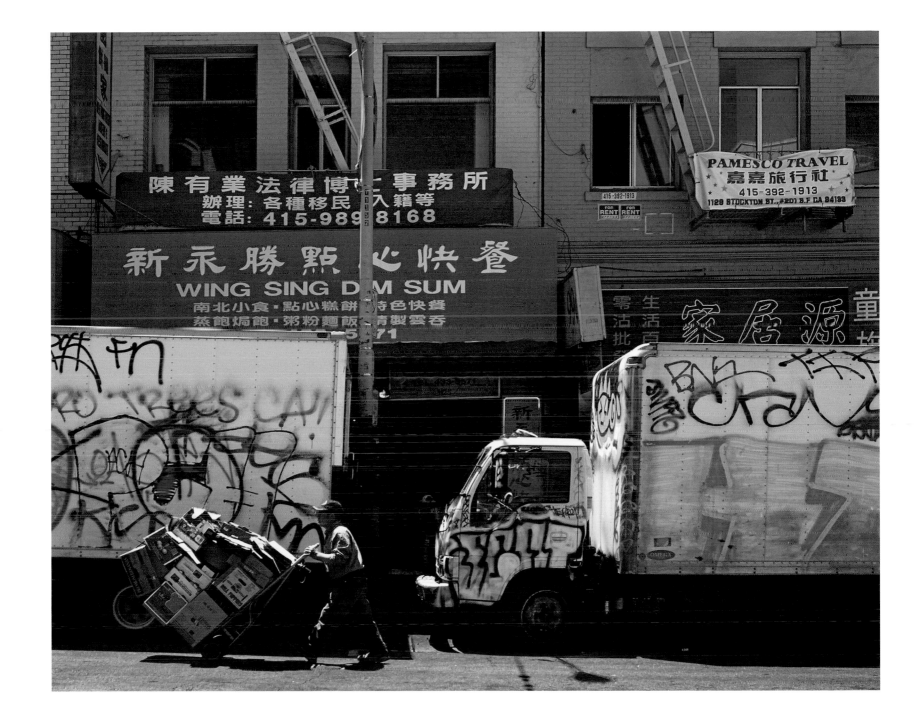

Lower on the Driver's Side

Iron pipes and pine boards frame this four-part shed. Corrugated galvanized steel covers the roof, and the sides are walled with sheet metal and Masonite. The antlers at the top have seven points that were becoming eight in the year the buck was shot. Whatever is stored at top left is masked with plywood, but on the right we can see a toy John Deere tractor, a box that held a fragile part for a Honda, a black tub used to mix mortar, and an upside-down stack of plastic buckets. Below, on the right side, are a folded aluminum ladder, a galvanized steel trash can, a spray can, scrap lumber, and at the lower right corner, two dead batteries. Welding equipment and a one-cylinder motor fill a two-wheeled trailer with its hitch held up by a wire crate. Backed in on the left is a '79 Ford pickup that rides closer to the road on the driver's side. The owner must have traveled many a rough mile without a passenger to balance his weight. The front plate bears the silhouette of a donkey and names the Centinela Ranch, in Chimayó, New Mexico. Among the ranch's breeding stock are mammoth donkeys, meaning that the jacks stand at least 56" high at the withers and the jennies at least 54". Behind the truck are a broom and a ten-foot ladder. Mounted on the wall to the left, where it fades into the darkness, is a God's eye made of yarn wound around spokes, each one tasseled at the tip.

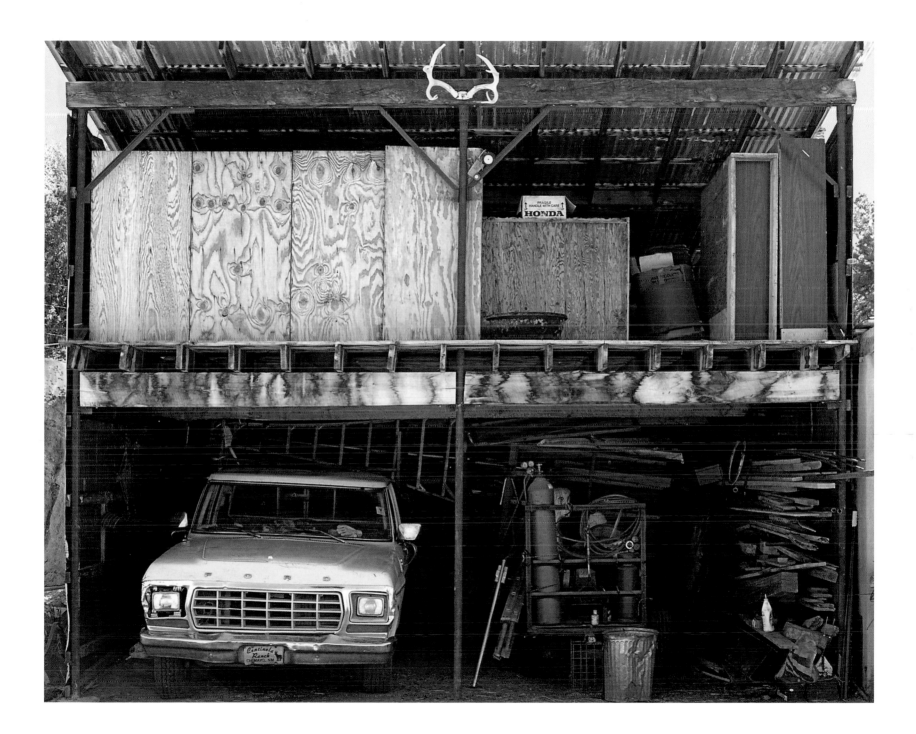

Carl Nielsen's Cantata

Moored in the canal in front of this orange-yellow building is a cargo boat converted into a houseboat, with a parasol folded shut on the foredeck. Elsewhere in Copenhagen are other buildings whose red bricks have been covered by layers of lime wash mixed with dark yellow ochre, and other houseboats. This one floats in Frederiksholms Kanal, marking the southwest side of Slotsholmen, the "Castle Islet" at the ancient center of the city. Moored to the houseboat is a motorboat the owner uses to make short trips around the city, one hand on the red throttle and the other on the handle of the rudder. The building, number 28B, dates from 1711. It houses the sculpture school of the Royal Danish Academy of Fine Arts. Above the entrance, a plaque and two bronze busts mark this as the place where father-and-son sculptors H. V. Bissen and Vilhelm Bissen had their workshop from 1842 to 1913. On June 9, 1925, a passerby might have caught the words of a song about apple blossoms shedding their petals. In a garden somewhere inside, Carl Nielsen was conducting a cantata that celebrates youth, this on the occasion of his sixtieth birthday. Today, in front of the entrance, a delivery boy is stepping off his cycle to lift the lid of the yellow box that carries his cargo. Beyond him, across a courtyard, two dark triangles on a yellow sign warn of danger behind closed doors.

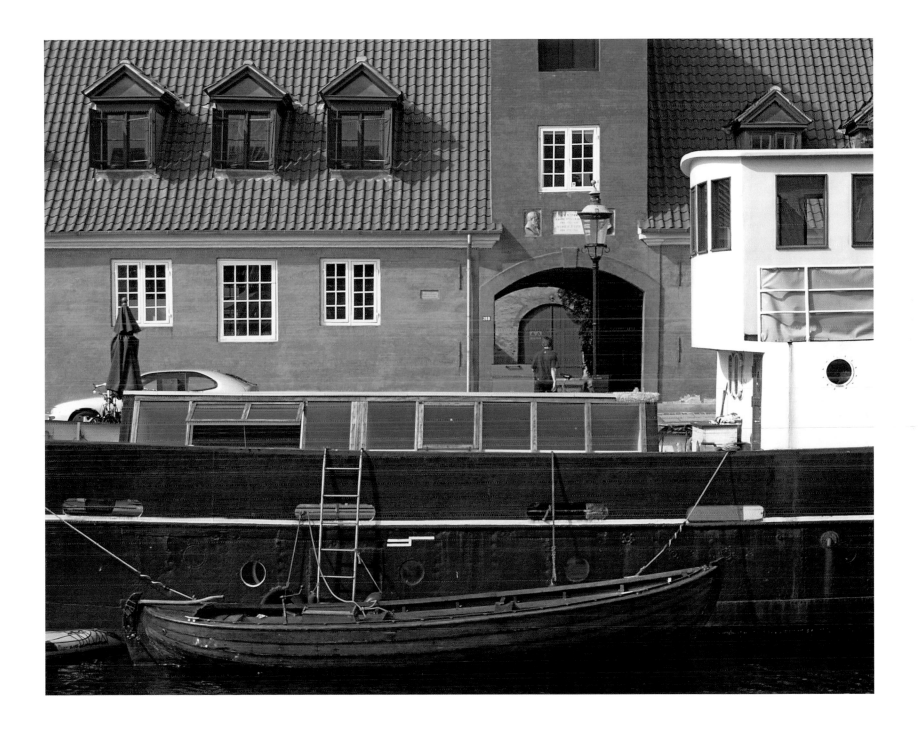

The Car That Saved Ford

Parked in front of this abandoned house is a sleek, slab-sided Ford V8 sedan, advertised as "the car of the year" in 1949 and described by the auto industry as "the car that saved Ford." The current owners, who live in Punta de Agua, New Mexico, have taken a step toward restoration by fitting it out with whitewall tires. They removed the old paint and applied a matte undercoat, but left the dent in the hood intact and have yet to add a coat of lustrous enamel. As for their house, they left it to the weather when they built a new one behind it. Rain has thinned the whitewash, exposing the brushstrokes. Under the plaster are courses of adobe bricks made from local earth, the same earth that colors the tire tread. The plaster would not have separated from the wall if the builders had nailed chicken wire to the bricks before applying it. Beneath the bricks a shallow foundation of local flagstone has shifted, creating a gap between the left side of the wooden window frame and the adjoining wall. Traces of red paint remain on the frame. The glass is gone, but remnants of shiny copper screening hang in the openings. It is now September, late in the rainy season, and the weeds inside the house have grown tall. Visible beyond the upended bedsprings and the open back door is the cab of a blue pickup with its tinted windows rolled up. Beyond that, a new horse trailer gleams in the sun.

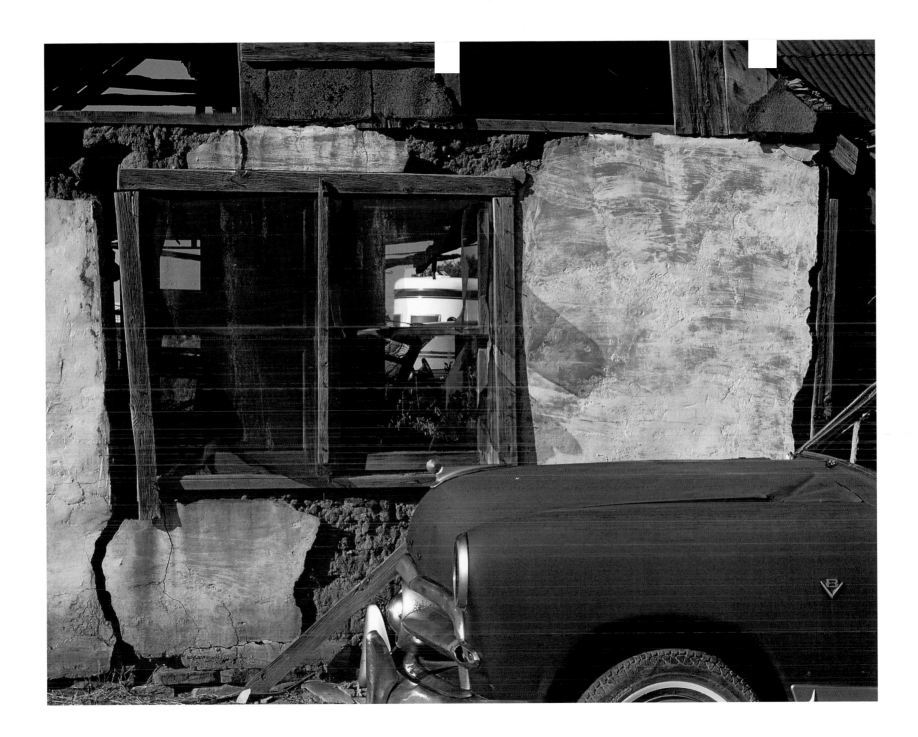

Joseph Sutro's Underworld

Now these walls expose their rebar to the salt air, but there was time when they supported the power plant and laundry for the world's largest glass-enclosed bathing pavilion. Housed under the same roof were six saltwater pools with different temperatures, 500 dressing rooms, seating for 7,000 spectators, a balcony for an orchestra, two restaurants, and a museum that featured stuffed animals. All bathers were provided white towels and black wool swim suits, and the laundry was capable of washing as many as 40,000 towels and 20,000 suits in a single day. Joseph Sutro, a Prussian emigrant to San Francisco, got the idea for the pavilion in 1881, while looking at tidal pools near Point Lobos. He chose a building site near Seal Rocks, and by 1896, the Sutro Baths were ready for bathers at 10¢ a head. The baths were closed in 1953 and the pavilion burned down to the foundations in 1966. At the time, local Satanists had been saying there were tunnels underneath the pavilion, providing access to the surface of the earth for malevolent beings who live in the underworld.

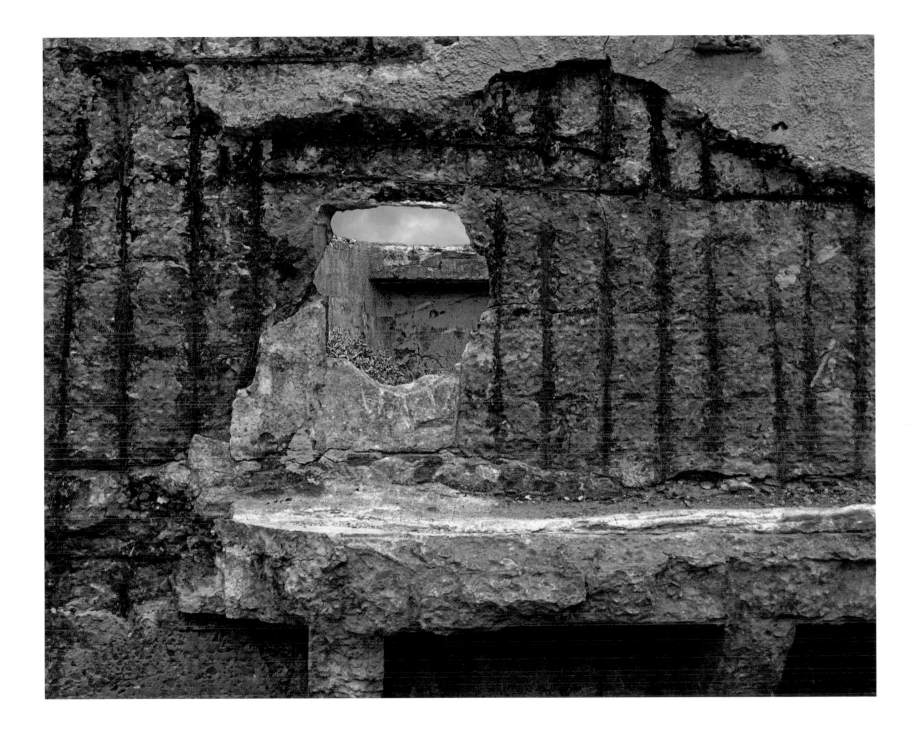

Herodes Atticus Hosts Puccini

A stage set is under construction here, in what remains of a classical theater. Four carpenters admire their handiwork, two on the balcony at left and two at front center. Visible at lower left are the bottom rows in a great semicircle of marble seats. If the stage had been built in the Greek style, it would have been the same width as the distance between the closest front row seats at each side, but this stage is wider, in Roman style. The architect followed the writings of Vetruvius in making the stage five feet high, but the carpenters have added a superstructure that reduces the view from the lower seats. The original backdrop was three stories high clear across, reaching the same height as the semicircular portico that rose behind the topmost row of seats and sheltered theatergoers from showers. Vetruvius describes the reason for the equal heights as acoustical. Beyond the backdrop is a city, and the white building adorned with cornices is distinctly Greek. We are in Athens, looking down on the Odeon of Herodes Atticus from the southern rim of the Acropolis. He built this theater in the year 161, in memory of his wife Aspasia Annia Regilla. The carpenters have only a week to go before the June opening night of the National Greek Opera's production of Puccini's *Turandot*. A Chinese emperor will hold court from the high throne at stage center, and his daughter will pose three riddles to her suitors.

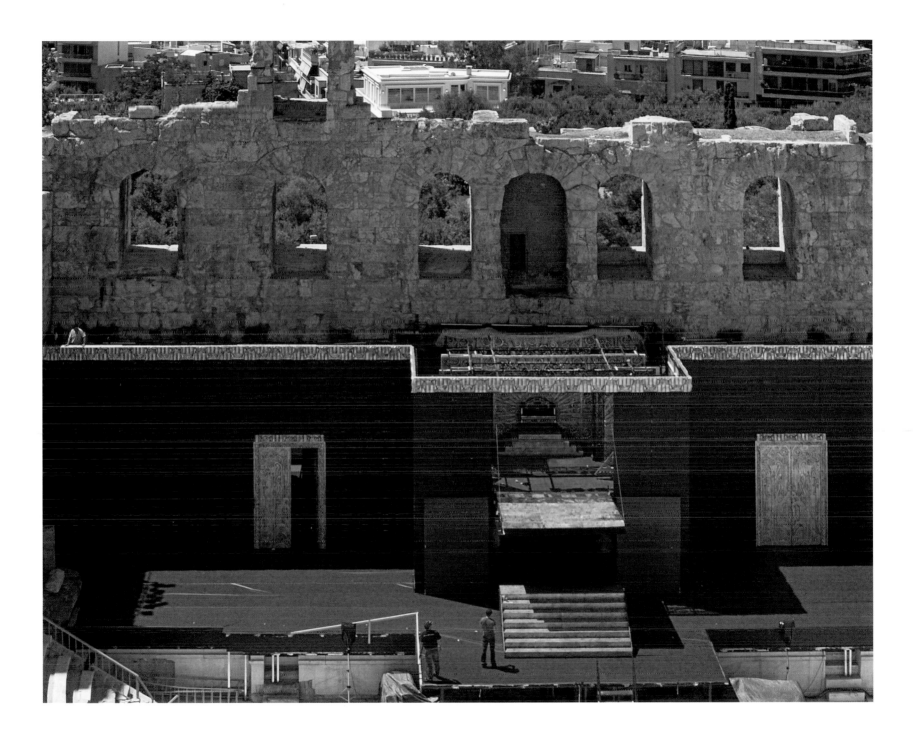

Temple of the Elements

The dirt road that once connected Albany with Boston runs past this clearing, climbing out of New Lebanon, New York, on its way across the Berkshires into Massachusetts. From 1785 to 1947, this land belonged to a commune of the Shaker Society. Mother Ann Lee, the founder of the Shakers, embodied the maternal side of God. Members of the society were celibate but sought ecstasy in dances that brought them closer to the day when the Second Coming would reveal the feminine side of Christ. In 1975, the land passed to a new commune, The Abode of the Message, founded by Pir Vilayat Inayat Khan of the Sufi Order International. He built a temple in this clearing, calling it The Mountain Sanctuary. In 2003, it burned down, leaving the marble steps, concrete foundation, anchor bolts, and charred door frame shown here. His son and successor, Pir Zia Inayat Khan, has been transforming the ruins into The Temple of the Elements, guided by Green Hermeticism. He plans to leave his temple open to the sky.

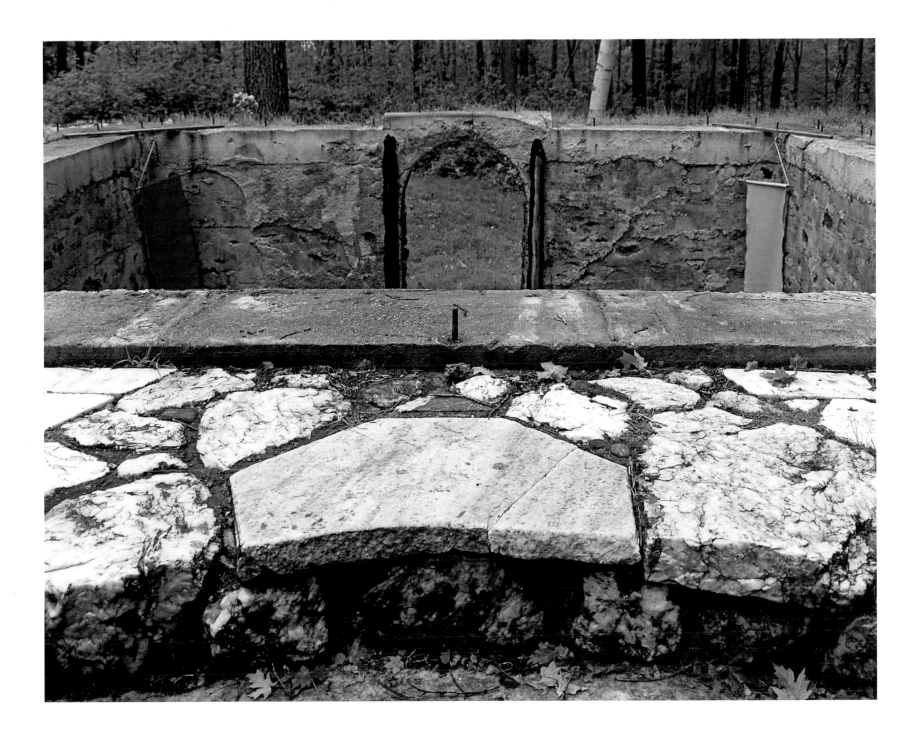

After the Last Ball Game

For several days the sun has stood still, rising and setting at the same places on the horizon. At midday, it comes as close to being directly overhead as it ever does this far north, 35° from the equator. On the northerly parts of these walls and the broken sandstone on the slope beyond, the shadows are as shallow as they ever get. Behind us are the hundred roofless rooms of what was once the village whose Hopi name, Wupatki, means "tall house." The oldest walls were built around 1025, using local sandstone and pieces of lava from a nearby flow. A generation or two after that, the villagers heard a rumble, felt the ground shake, and saw the birth of a new volcano, burning at the distance of a day's walk to the south. They felt a dry rain that enriched the red earth with gray ash. We stand at the west end of the ball court they built, the northernmost of all the courts that begin down in Guatemala and end here, not far from the Grand Canyon. Once there was a spring just outside the village, but that went dry long ago. By 1300, everyone had left. The ball court was excavated and restored in 1965, but the rules of the game went away with the people who played it.

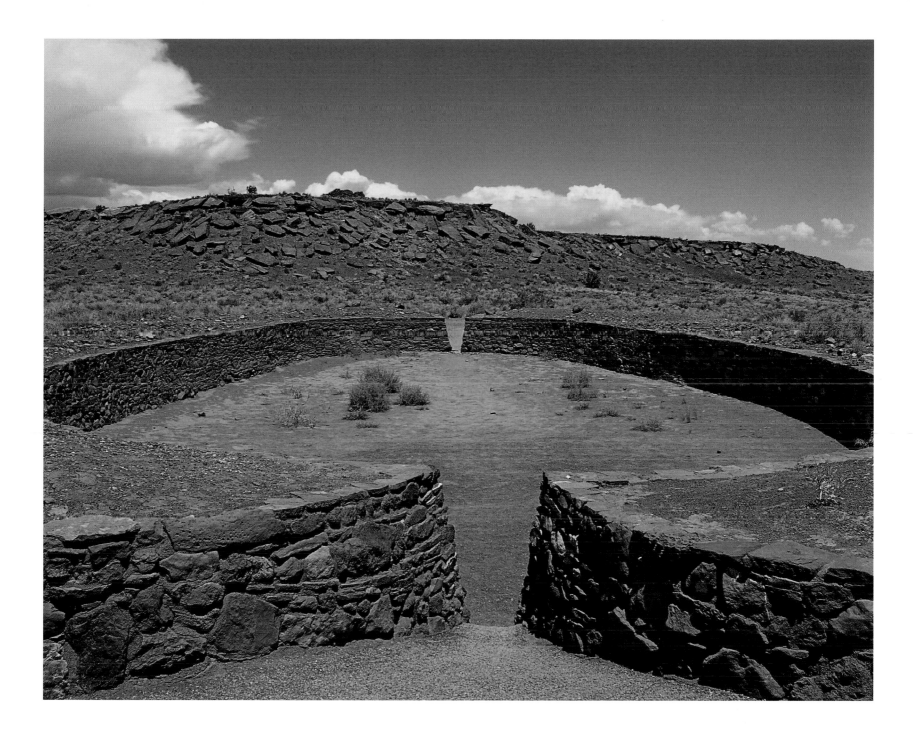

Sound of a Baby Crying

The black stones are flint, chipped here and there but otherwise rounded and smooth. They were brought from a tidal zone, where they were rolled and pounded by surf. Mixed with the flint are pieces of light gray and honey-colored sandstone, together with orange bricks, all bound together by chalky mortar. The stones and chalk are native to Kent, the bricks are Roman, and the masonry belongs to the facade of St. Mary's Church in Reculver. When the Romans built a fort here in the second century, they called the place Regulbrium, from a Celtic name meaning "at the promontory." Raculf was the name in the Old English of 669, when the Saxon King of Kent granted land for the building of a small mission church on the ruins of the fort. The gently pointed arch and the straight lines of the molding above it came with a Norman expansion of the church in the late twelfth century, when Gothic forms made their first appearance. Beneath the wooden beam was the front door, sealed when the church was abandoned in 1809. By then the North Sea had advanced far enough to take away the churchyard and force the villagers to move inland, where they built a new St. Mary's. Visitors to the old site reported hearing the sound of a crying baby. Recently, archaeologists have found the skeletons of several infants beneath the remains of the Roman walls.

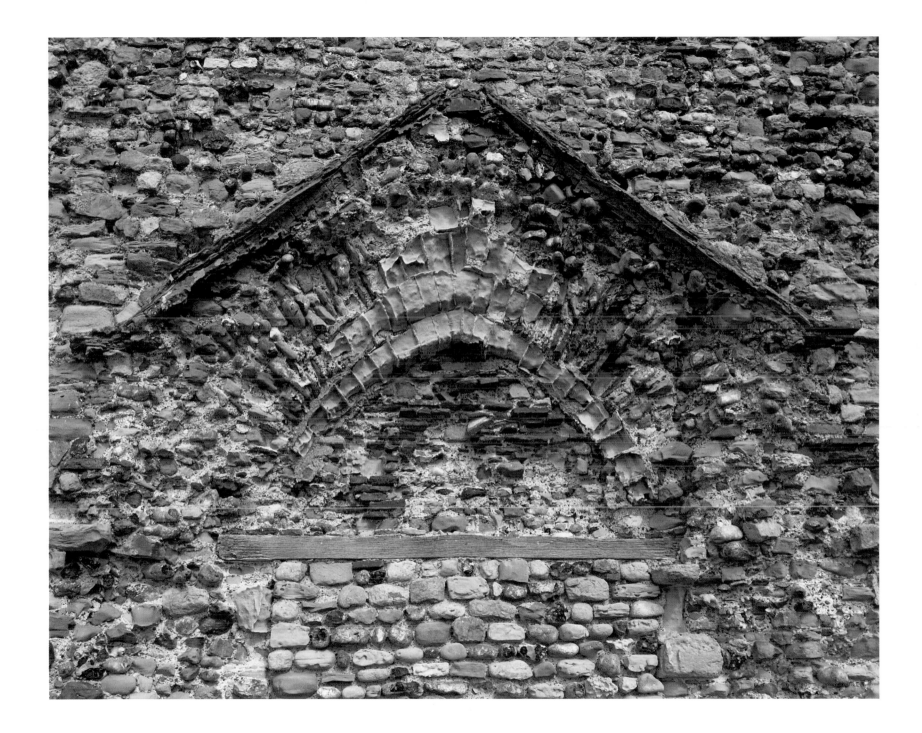

Three Different Calibers

The builders of this ranch house laid local fieldstone in mortar made from the dark soil of the canyon floor on which it stands. For the final coat of plaster, they brought in lighter soil from nearby slopes and mixed it with lime. The source of the plaster's warm color is volcanic ash, spread over the area by a massive volcanic explosion a million years ago. For some reason, the front wall has survived better than the back wall, which barely rises above the rabbit brush that fills the interior space. Nearly all the wood that framed the windows and doors and supported the roof has been hauled away, along with the glass and roofing material. Or perhaps the construction never went very far beyond what we see. Bullets of three different calibers have been fired into the plaster, many of them with no particular target in mind, but the cluster of small holes to the right of the doorway, halfway down, centers around the name BILL MORRIS. It would seem that the O was the intended target, since it has been obliterated by a pair of holes right next to each other. On this February day in Peralta Canyon, in the Jemez Mountains of New Mexico, the only sign of active ranching was a solitary heifer, frightened at the sight of people.

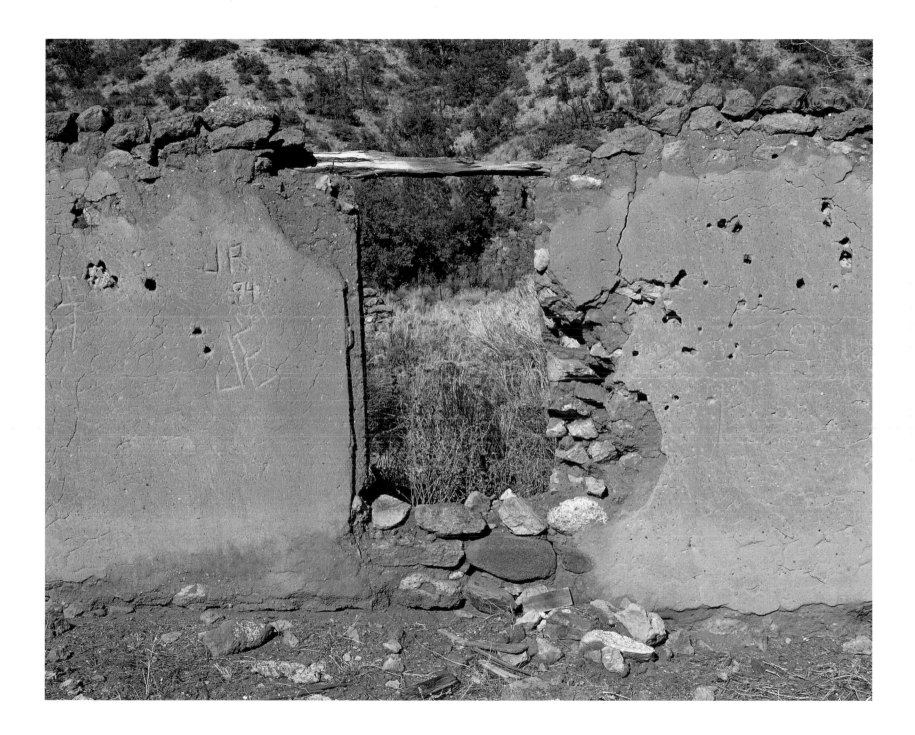

No One Ever Lived Here

Here would seem to be a ranch house with a corral out back, abandoned some time ago. But wait—the ground in front of the door has not been hardened by years of foot traffic. The door frame bears no sign of hinges. The ground inside the corral has the same weeds as the ground outside, as if horse hooves and manure had never had any effect on the soil. The stripes of pink paint above the door and window seem arbitrary, and they have nothing to do with the vernacular architecture of northern New Mexico. The blue paint below the window was applied in a thin, uneven wash, as if to simulate weathering. As for the window itself, it hangs on the wall like a picture. Behind the broken glass are the ragged remains of a curtain that must have filled the frame and concealed the beaverboard backing, and behind the backing is the wall. The only thing inside the house is a Cinesaddle, a canvas cushion made for shooting scenes from low angles that would challenge a tripod. It must have been left here ten years ago, when video cameras were aimed at Kenny Chesney in a Stetson and a brunette in a chambray peasant skirt. Chesney danced with her while he lip-synched his first big hit, "She's Got It All."

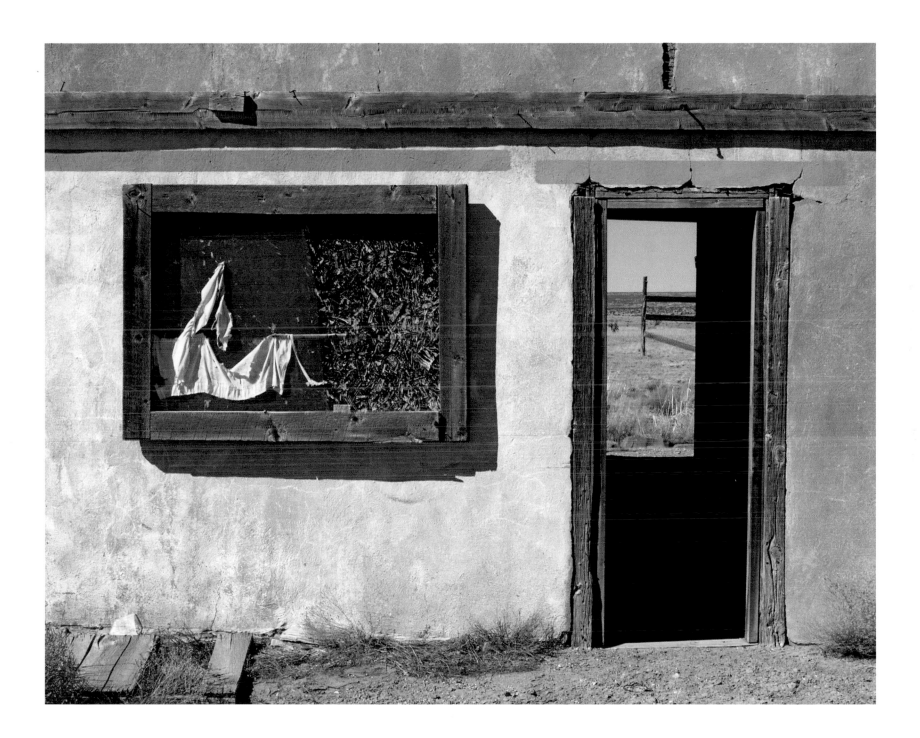

Bird Blind

The open door invites us to enter this photo and hunting blind in the Alabama Swamps of western New York. The floating dock that brought us this far was assembled by Jonathan Hoste and other members of Boy Scout Troop 40 in Wrights Corners. Christopher Clarke of Troop 6066 in Indian Falls contributed more than 160 hours to the building of the blind, bringing him closer to the rank of Eagle Scout. When a reporter from *The Batavian* asked him why he tackled this project, he replied, "A lot of people from all over come here, so this is something that is pretty much for everybody." During the hunting season, only disabled persons are allowed to use the blind, but anyone can use it at other times. Reservations are available at the headquarters of the Iroquois National Wildlife Refuge. The cattail camouflage on the door and wall panels was made with a stencil. Visible through the open door are a railing with notches for the barrels of standing shotguns, a metal ramp that can be lowered into the water, and a wooden bench. In early May, sitting inside with the door closed behind us, we won't have to wait long to see kingfishers, barn swallows, tree swallows, and great white egrets.

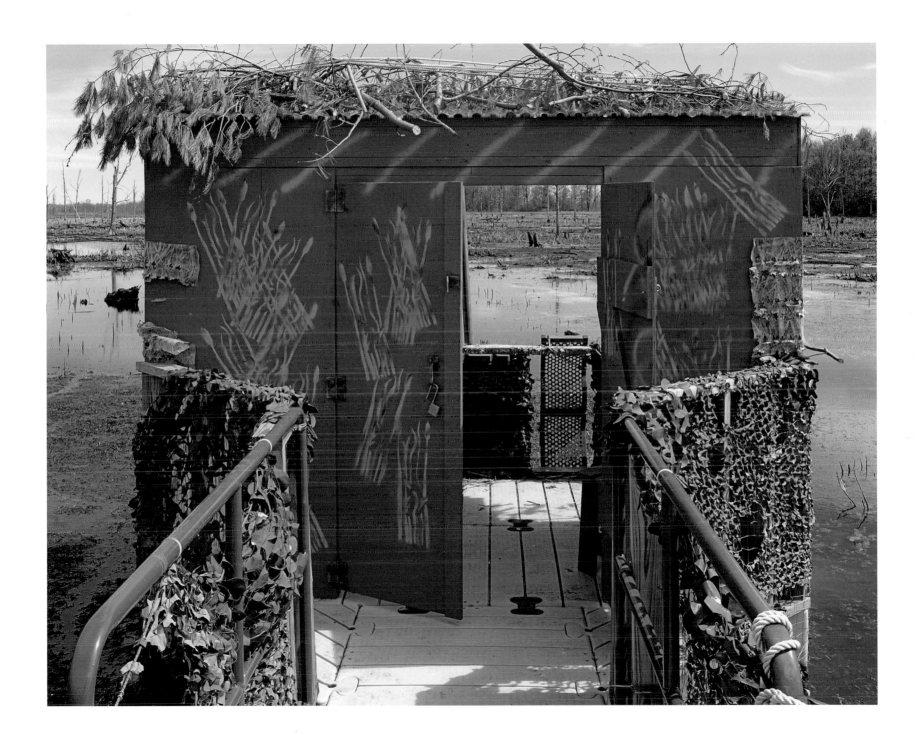

Secrets of the Rampart

Earthworks form the outermost rampart of Kronborg Castle in Helsingør. On the outer side are the waters of the sound that connects the North Sea with the Baltic. On the inner side are many doors like this one, providing access to the casemate that runs along inside. In the sixteenth century, there could have been stacks of arms behind this door, or armed men in the service of the King of Denmark, men whose movements could not have been seen from ships on the outer side. In recent years the granite retaining wall has been restored, but the plaster is falling off the brick wall that frames the door. The inscription on the stone plaque above the arch has long since become illegible, and the planks of the padlocked door are rotting where they touch the ground. One of them has broken off, providing an entrance for rodents or perhaps rabbits.

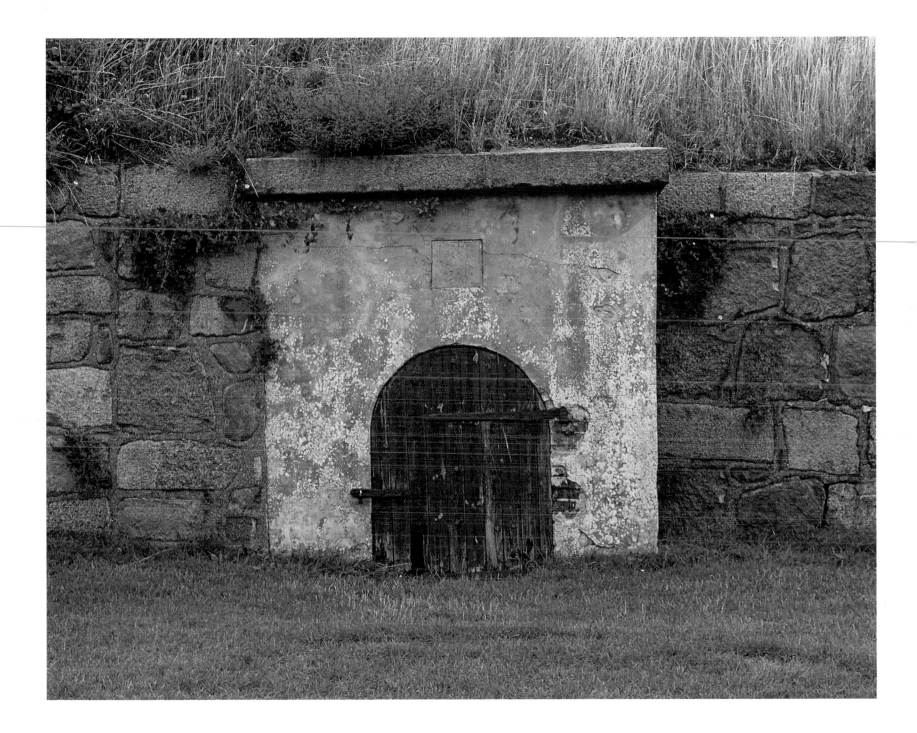

View from the City of Hadrian

Looking up at the Acropolis through this solid marble arch built in the year 132, we see the solid marble Parthenon, built five centuries earlier. It was reduced to ruins in 1687, when a shell fired by Venetians hit a Turkish powder magazine. In the middle ground is a modern building whose marble veneer is coming loose at the upper corner. An inscription runs above the arch, and if we could trace out all the letters, they would read:

<div align="center">ΑΙΔΕΙΣΙΝΑΔΡΙΑΝΟΥΚΟΥΧΙΘΗΣΕΩΣΠΟΛΙΣ</div>

"This is the city of Hadrian, and not of Theseus." But the city of Hadrian is not the one we see before us—rather, it is the city in which we stand. Directly behind us are the ruins of the Temple of Olympian Zeus, whose completion in 132 was made possible by Hadrian. If we walk through the arch and look back at the inscription on the other side, it will say:

<div align="center">ΑΙΔΕΙΣΙΝΑΘΗΝΑΙΘΗΣΕΩΣΗΠΡΙΝΠΟΛΙΣ</div>

"This is Athens, the ancient city of Theseus," again telling us where we stand and what lies behind us. It was Theseus who entered the labyrinth at Knossos, killed the Minotaur, and found his way out by way of Ariadne's thread. On his return to Athens he became king, with a palace up there on the Acropolis. The arch was built by Greeks in honor of Hadrian, who sponsored more public works in Greece than any other Roman emperor.

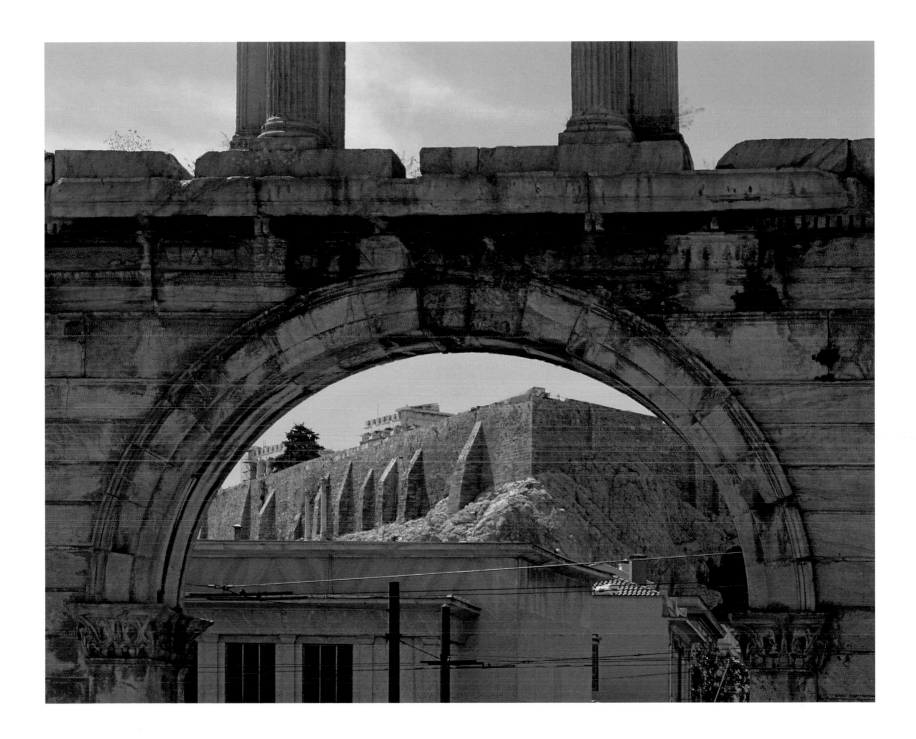

View from the Bishop's Palace

Were it not for the great earthquake of 1773, the walls around this opening would be ornamented with a layer of carved stucco. Instead there is only an undercoat, pitted with a chisel so as to hold the layer that was shaken off. We are standing inside a palace built for the Archbishop of Guatemala at the end of the seventeenth century, looking south through a doorway that pierces the front wall. The wooden grill is recent, added to make the ruins of the palace more presentable. Exterior stucco is still in place on the building across the street, the former home of a seminary where the sons of indigenous leaders were schooled. The blue shape beyond is the Volcán de Agua, with a cloud forming around its summit even on this afternoon in the dry season. Unlike its twin, the Volcán de Fuego, Agua does not manifest its power with smoke and fire. In 1541, when heavy rains were followed by an earthquake, Agua sent down a mass of water and mud that buried what was then the capital of Guatemala, a place now known as Ciudad Vieja. In 1543, a new capital was founded in the place where we now stand, still in plain sight of Agua. After the earthquake of 1773, a newer capital was founded at the place now known as Guatemala City, leaving the previous capital to be called Guatemala Antigua. By now it is simply known as Antigua, meaning "old" or "antique," and that is what it is.

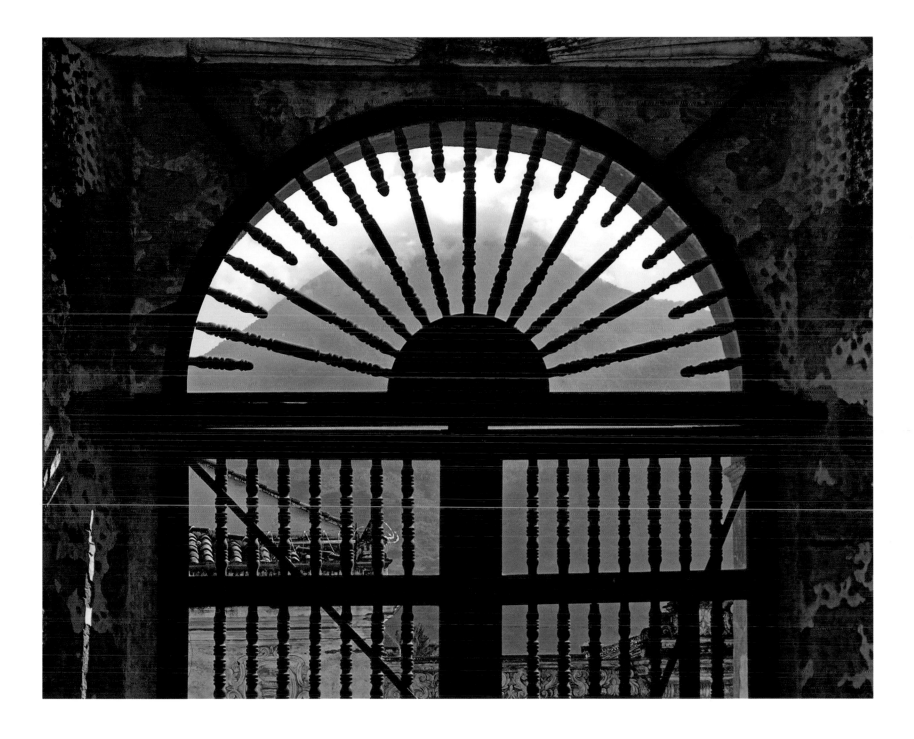

Light from a Hole in the Earth

A door in the sanctuary of this church leads to a tiny chapel with a dirt floor, and in the floor is a hole filled with powdered earth. Pilgrims mix the earth with water and drink it or apply it to their bodies. Long ago the hole had its own water, and people from nearby Tewa villages came to get mud from the bottom. On the nearby hillsides they gathered *tsimayoh*, a kind of quartz they chipped to make arrowheads, and they named this place after the quartz. When speakers of Spanish established a village here three hundred years ago, they called it Chimayó. On the night of Good Friday in 1810, while Don Bernardo Abeyta was doing penance, he saw a light coming from the hole, which was already dry by then. Digging in the earth with his bare hands, he found a wooden crucifix resembling Nuestro Señor de Esquipulas, a miracle-working image in Guatemala. In 1816, he built the church to house the crucifix and the hole. Pilgrims seeking cures have been coming here ever since, from all over New Mexico and far beyond. In 1930, Paul Strand aimed his camera upward from a low position to the left, creating an arid black-and-white scene with adobe walls against a rocky hillside and an empty sky. In 1950, Ansel Adams shot the facade straight on but from a greater distance, framing it with the cottonwood trees whose leaves cast shadows on the churchyard wall in this picture. The roses climbing the gates were planted after his time.

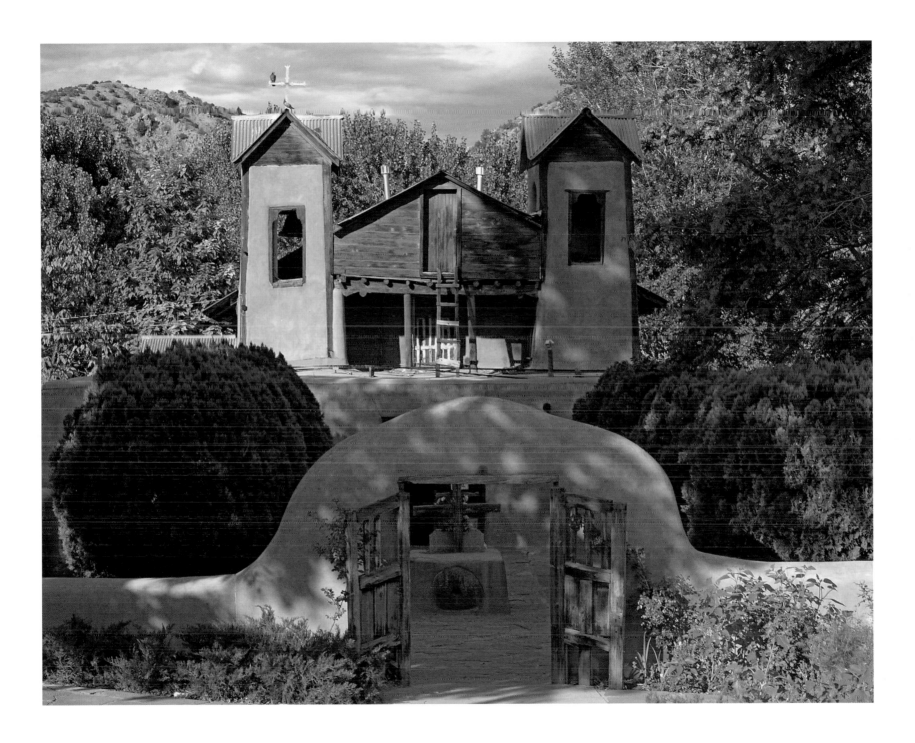

Uptown Temple

Among the images in the bronze medallions on these doors are Noah's ark, the Ark of the Covenant, and a menorah. There are six images in all, repeated on each pair of doors but with different arrangements. If we walked clear around this temple, we would find that it has eight sides. If we went inside, we might hear the sound of a recently refurbished Skinner organ, and we might recognize the Ner Tamid as the work of Tiffany Studios. The sanctuary is on the east side, so that the congregation faces toward Jerusalem. The doors are on the southwest side, catching the afternoon sun and the shadows cast by live oaks. All the other buildings in this uptown New Orleans neighborhood are rectangular and all are aligned with the streets, but these doors face diagonally across the intersection of St. Charles Avenue and Calhoun Street. They belong to Temple Sinai, built in 1927 for a Reform congregation founded by German immigrants in 1870. The architects, Moise H. Goldstein and Emile Weil, were inspired by the mosques of Istanbul converted from the Byzantine churches of Constantinople.

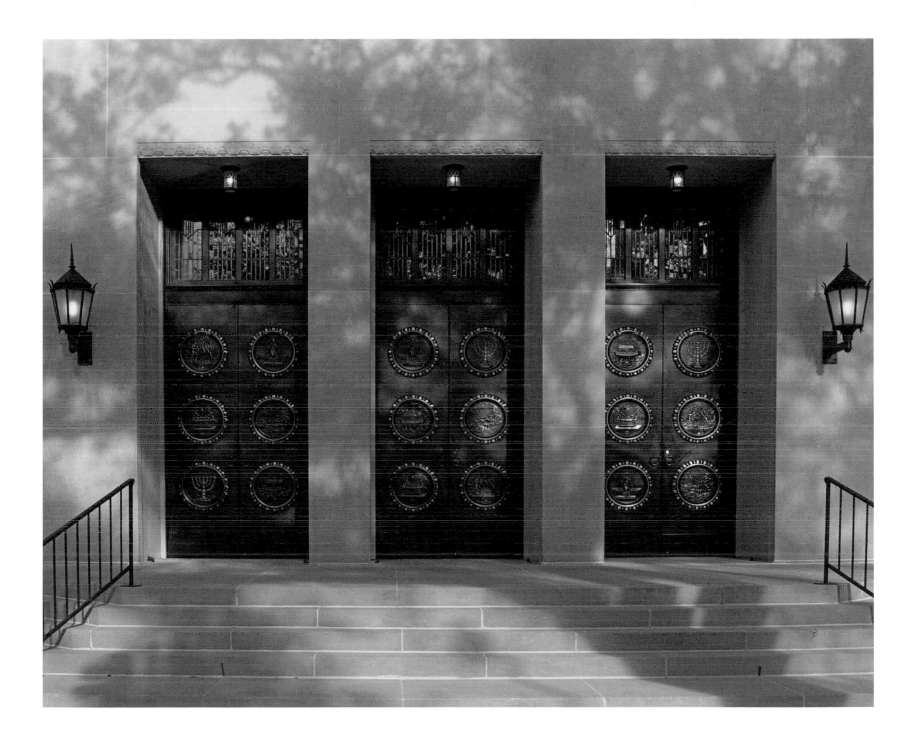

Ransom for Captive Christians

The empress who greets visitors to this church is Nuestra Señora de la Merced, "Our Lady of Ransom." In 1218, in Barcelona, she appeared to San Pedro Nolasco, instructing him to found a monastic order devoted to ransoming Christians held captive by Moors. He stands in the niche to the right of hers, wearing the vestments of his order. In the opposite niche is his most notable recruit, San Ramón Nonato, "St. Raymond Not-born," so named because he was cut from his dead mother's womb. He wears the vestments of a cardinal, even though he died on the way from Barcelona to Rome for his ordination. Below Our Lady and above the arch over the entrance is the shield of the Mercedarian order. When this church was completed in 1767, it graced what was then the capital of Guatemala, the town now known as Antigua. It survived the great earthquake of 1773 because the architect, Juan de Dios Estrada, made its walls very thick in relation to their height and restricted the number and size of the windows. If this were Holy Week, the entrance would be wide open, allowing for the passage of saints on palanquins. But on this quiet morning in May, only the small doors within the large ones are open. A beggar with a walking stick stands near the left-hand door, which has a ramp for the handicapped, while a tourist in white knee-length shorts and white socks disappears into the darkness beyond the other door.

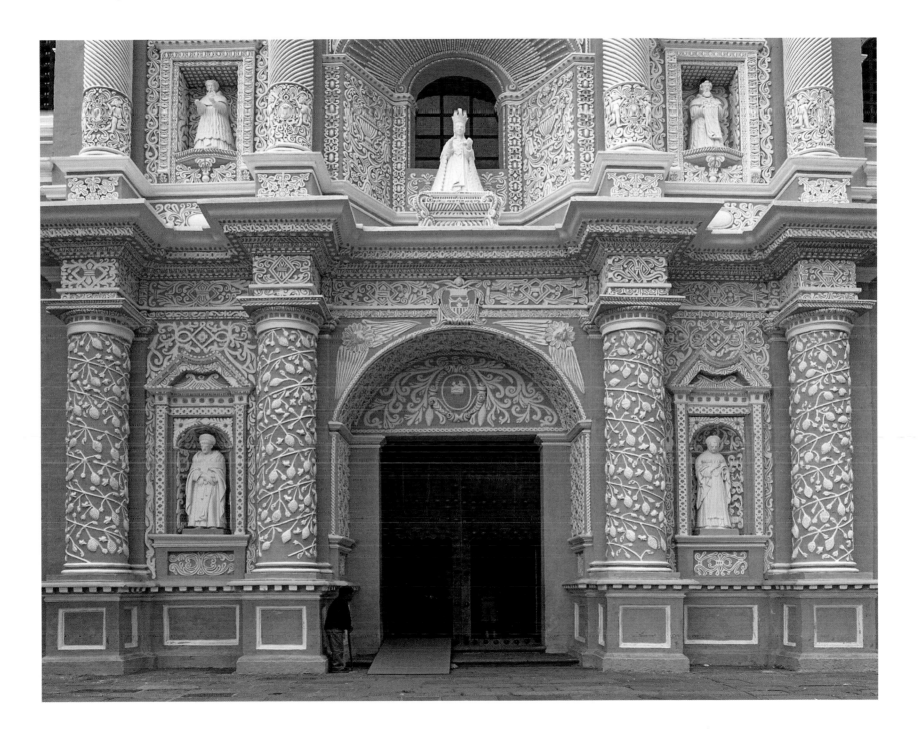

Waiting for Candles

It is a little past noon, so the lace curtains on this east window no longer filter the sun. On the horizon, the highest peaks of the Sangre de Cristo Range are still covered with snow in late April, but down here in the foothills, the ground is dry and the leaves are coming out. Wooden saints, along with a cow and some sheep, stand on the bare sill with their backs to the world outside. In the center is a Nativity scene with a praying angel on top. All the figures were carved by Marco Oviedo, a *santero* whose trade goes back to the eighteenth century here in Chimayó and other villages along the Río Quemado in northern New Mexico. Each one is marked on the bottom with a price. It is up to the buyers to have them blessed by a priest. In their present state, they merit neither candles nor an altar cloth.

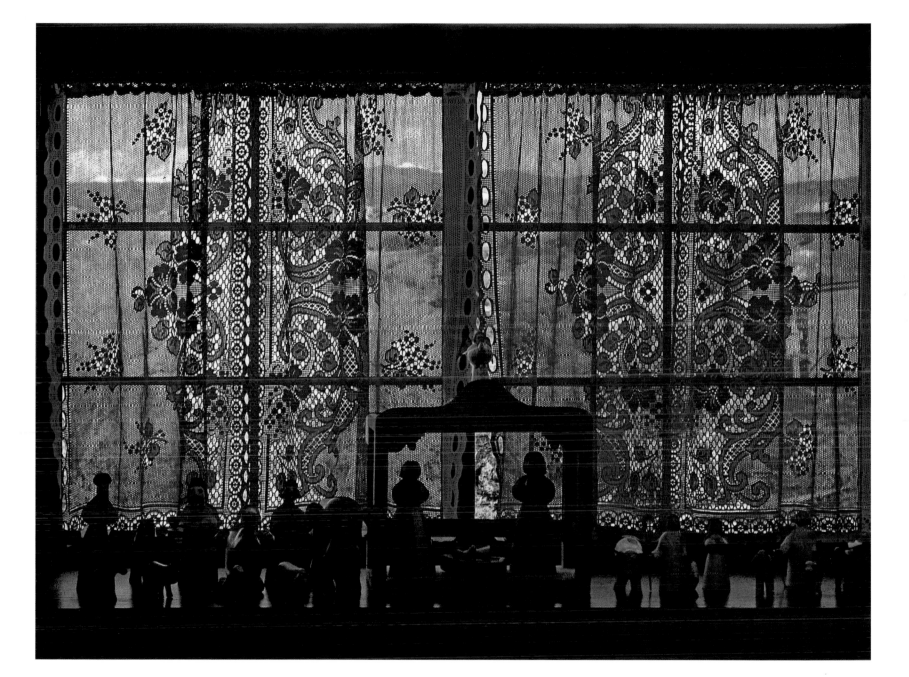

Lost Literary Foundation

It is late afternoon on the Kloveniersburgwal, the "Town Moat" that marks the eastern border of medieval Amsterdam. The sunlit buildings on the east side of the moat are reflected in the windows of this building on the west side. At the same time, the windows on the east side throw sunlight onto the western boats, car, and foundation stones. Number 86 is the home of Perdu, a literary foundation that runs a poetry bookshop and sponsors a reading series called "Fresh from the Knife." Whoever wrote on the chalkboard to the left of the entrance has renamed the place Medisch Centrum Perdu, "Perdu Medical Center," in recognition of a special event scheduled for this coming Friday. A medical ethicist and a feminist columnist, taking Susan Sontag's *Illness as Metaphor* as their point of departure, will share the stage with Oliver Oat and his Magnificent Moving Orchestra. Like other Perdu events, this one will be recorded and made available as a "Lost Podcast."

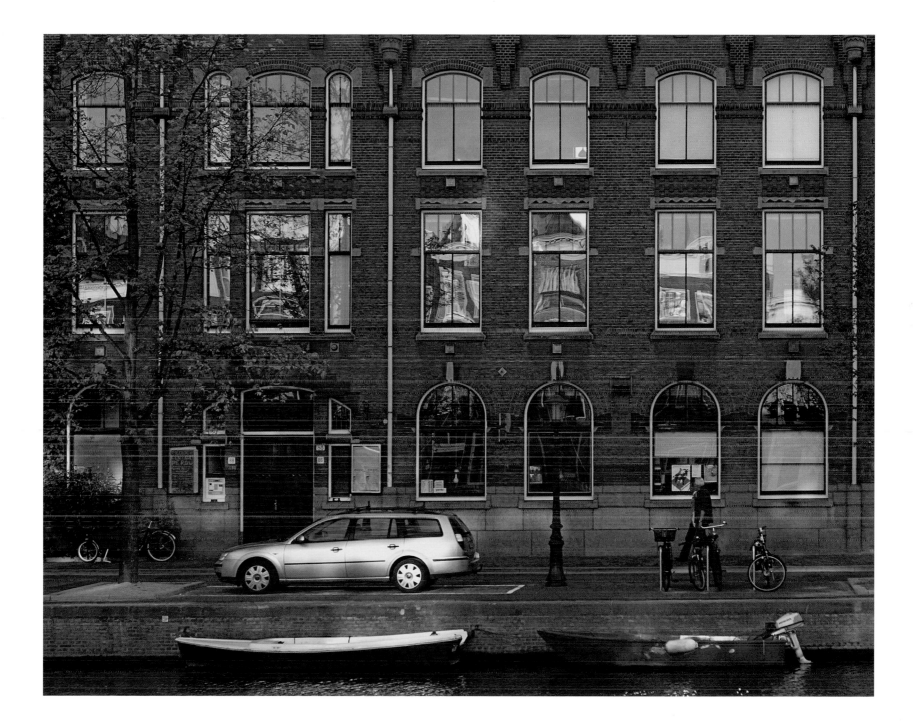

Datura Dilates the Pupils

We are in the BAY AREA, says the lettering in the top window. The sign hanging at upper right suggests that the half-price items on sale include tickets to ride the elevator to the top of Coit Tower, there to look out over San Francisco and the Bay. The ticket pavilion stands on the west side of Union Square, and visible to the right across Powell Street is the St. Francis Hotel, which survived the earthquake of 1906. Beneath the gray arch, a larger-than-life image of a model advertises Victoria's Secret. We stand deep in the shadow cast by the hotel, but the upper window of the pavilion mirrors a clear blue sky and the sunlit buildings on the opposite side of the square. There were plans to put a Jumbotron billboard on top of the white building at center, but that was ten years ago. Rising closer by is the shining spire of a recent sculpture by R. M. Fischer, made from parts of old street lamps. Squares of sunlight reflected from two distant windows strike the drawn shades of the pavilion. South America is the source of the plants. The fuchsia-colored flowers are those of a fuchsia plant, and the yellow flowers, called "angel's trumpets" by some, are those of a tree datura, *Brugmansia* arborea. The flowers, leaves, and roots of this tree contain scopolamine, an alkaloid that dilates the pupils in small doses. Larger doses induce visions, but they come with a high fever and are hard to remember.

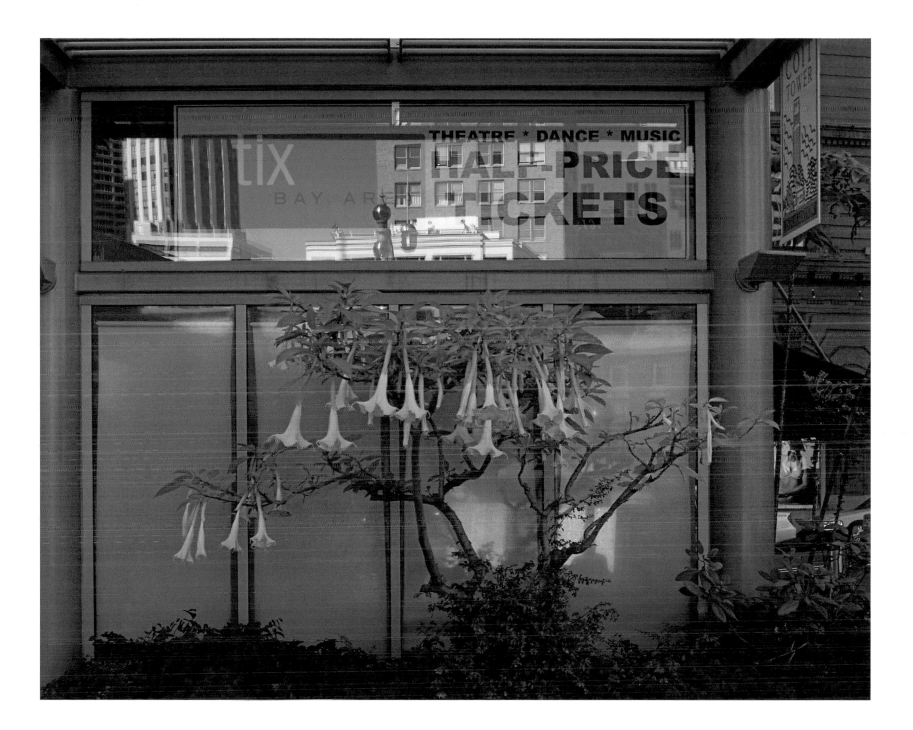

Lighting for Photographs

It is early afternoon in the canal house at Keizersgracht 609, and the skylight projects its shapes onto the east wall of the atrium. We are in the home of FOAM, the FOtografiemuseum AMsterdam. On the top floor is a library filled with photography books, but no one is up there at the moment. Here on the second level, a bridge supported by cables and paved with blocks of cobalt blue plastic reaches across the atrium to the low door of a freight elevator. The lettering on the wall to the right announces *Controle*, a ground floor exhibit of photographs by Emilie Hudig. She works from her sickbed in Rotterdam, documenting the latest round in her battle with Hodgkin's lymphoma. The track lights on the left are aimed at a deliberately overexposed photograph by Massimo Vitali, a panoramic view of a white beach filled with thousands of bathers.

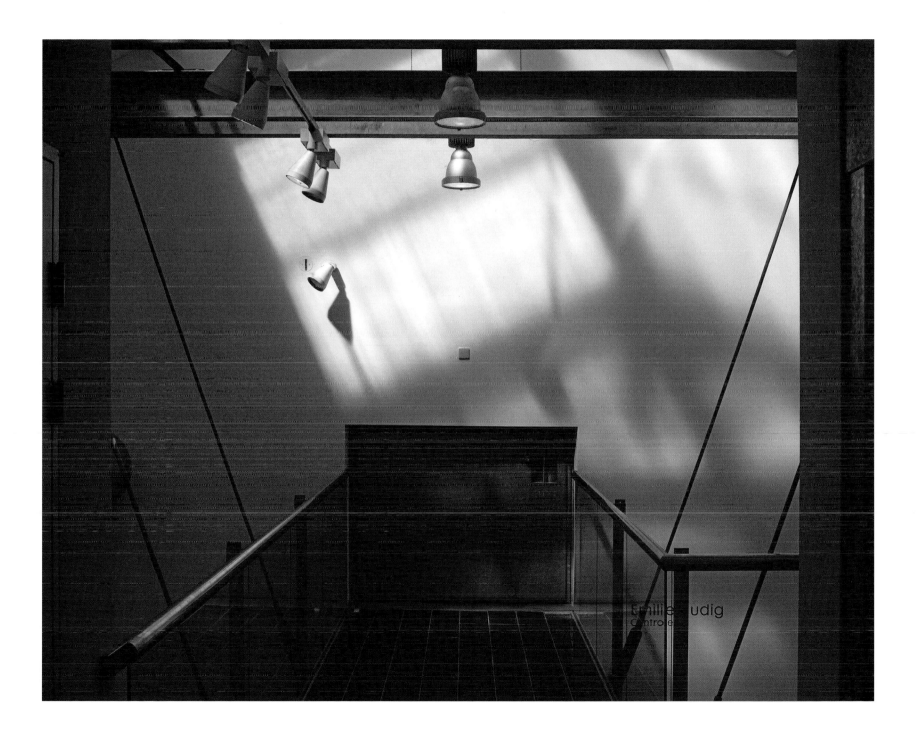

At the End of an Old Road

Only three or four travel trailers like this one still exist. It is a 1946 Westwood, manufactured in Los Angeles by a company that ceased operation in 1955. Emerging from the Pullman-style roof is the flue of the heating stove that was standard equipment in Westwood trailers. The roof is in good condition because it has an aluminum skin, but the matching metallic paint on the walls is peeling off, exposing the Masonite underneath. Even the Masonite is falling away to the left of the window, exposing the backside of a plywood interior wall. Visible below the window is a wheel well, but the wheels were removed when the trailer arrived at its final destination in a canyon east of Santa Fe, at the end of a logging road that is no longer passable. The deck and fence were built by a Vietnam veteran, using pallets made for a forklift. By centering the gateway on the window, he gave himself a wide view of his garden. He could see visitors from a long way off, but they got a full view of his front door only when they reached the threshold of his deck. Resting on the deck, at far left, is the metal frame of his chaise lounge, and next to that is the handle from his two-wheeled garden cart. Whatever he hung from the beam across the gateway, only the twisted blue wires that held it remain. One day he shot himself.

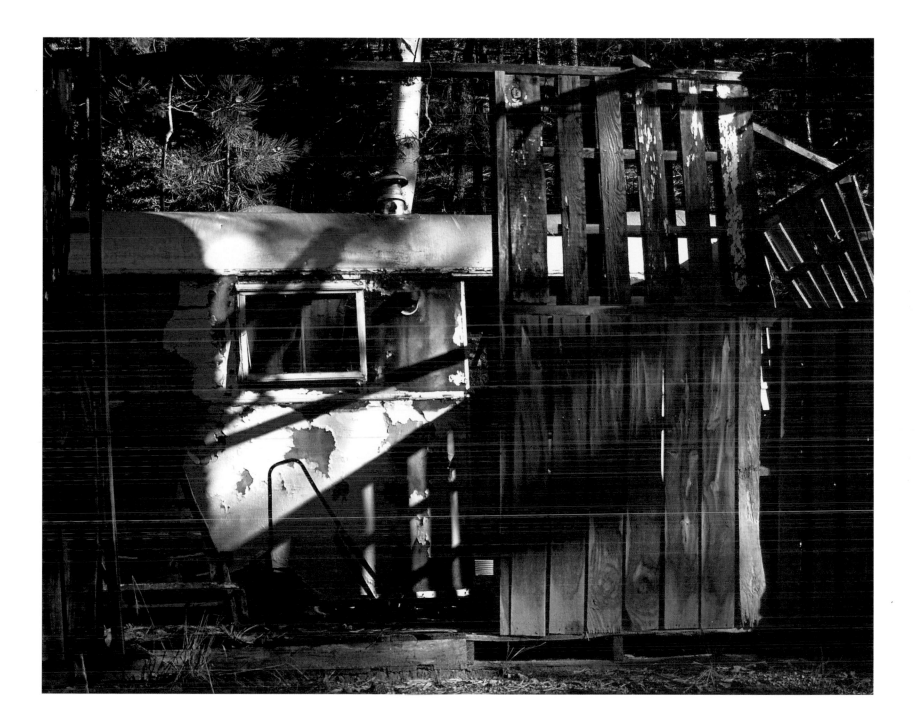

Life and Dreams in Chiapas

These windows face Jack Kerouac Alley, between Grant Avenue and Columbus Avenue in the neighborhood where Chinatown becomes North Beach. One window has blinds on the inside and the other has bars on the outside, but the employees of City Lights Bookstore have opened both of them partway. When City Lights was founded in 1953 by Lawrence Ferlinghetti and Peter D. Martin, it was America's first all-paperback bookstore. It is noon now, 57 years later. The store has been open for two hours and will remain open until midnight, on this Thursday in July or any other day. Shadows from a fire escape fall on a larger-than-life portrait of a Tzeltal Mayan woman from Chiapas. She looks into the alley from her place in a mural that celebrates the Zapatista movement, one of seven such murals in seven cities. All of them are based on a photograph of a lost original titled *Vida y Sueños de la Cañada Perla*, painted in 1998 in Taniperla, Chiapas, by Sergio Váldez Rubalcaba of Mexico City. When his work was destroyed that same year by the Mexican army, other artists painted copies on walls in Madrid, Barcelona, Bilbao, Florence, Mexico City, Oakland, and lastly, here in San Francisco. Among the titles issued by City Lights Publishers is a history of the Zapatista movement by Gloria Muñoz Ramírez, titled *The Fire and the Word*.

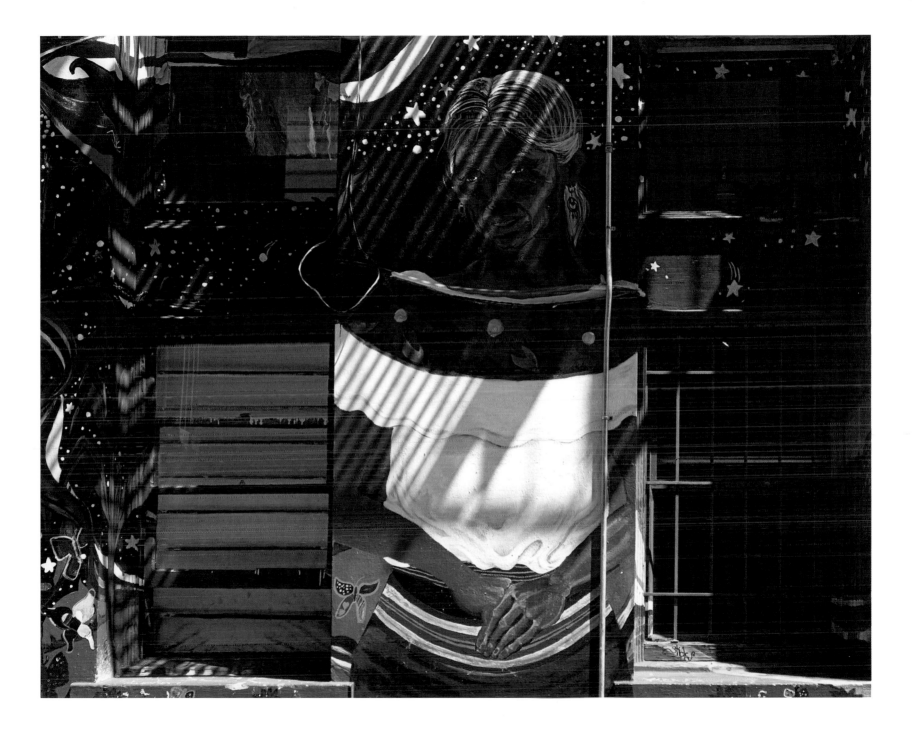

Before and After Katrina

On display where we cannot miss it is a book filled with photographs of New Orleans as it was shortly before Hurricane Katrina. The water reached the level of the very floor where we now stand, but that was several years ago. We are in the Maple Street Book Shop, in an old one-story house in uptown New Orleans. A sign on the porch says, "Give books—the presents of mind," and a sign inside tells us we are in the right place to "fight the stupids." Books fill all the shelves, the shelves fill all the rooms, and plastic-wrapped pictures of readings and signings fill the wall beyond the computer. Nothing in this house is perfectly plumb, nothing is perfectly level, and the floor creaks underfoot, just as it did when the store opened in 1964. That was the year when students first hit the streets to protest the war in Vietnam, Nelson Mandela was sentenced to life in prison, Lyndon Johnson signed the Civil Rights Act, Bob Dylan turned the Beatles on, and the Nobel Peace Prize was awarded to Dr. Martin Luther King Jr. Visible to the left of the computer monitor and dating from the same period are red, white, and blue bumper stickers that read "Eracism." On top of the monitor, new stickers with a rising sun on a black background advocate "love in the ruins."

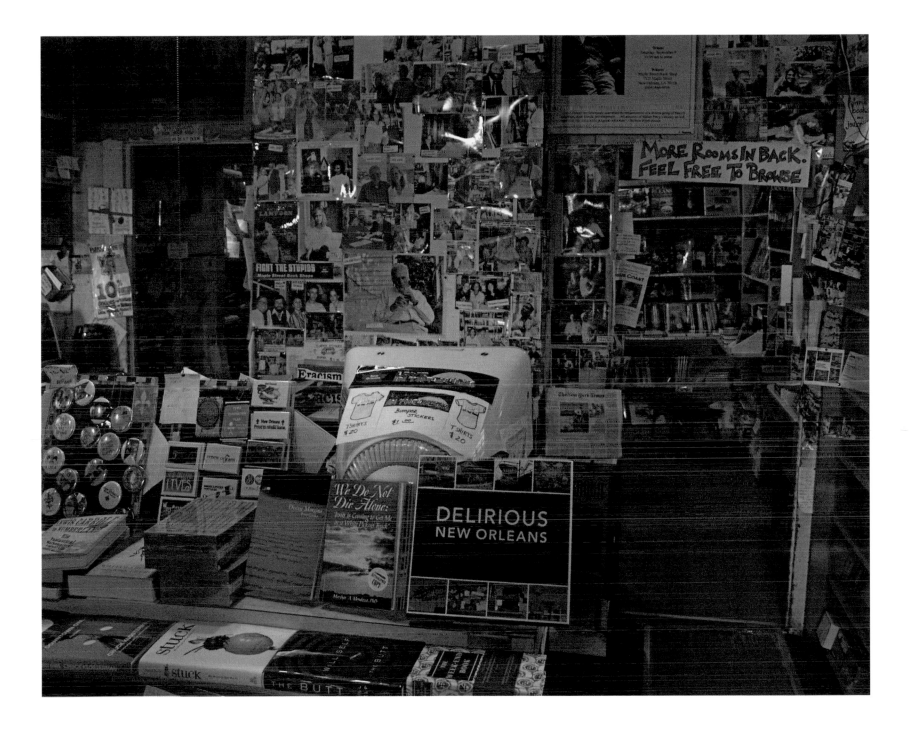

Almost Time for Lunch

The shelves in this tiny New York delicatessen window are lit, and the door stands open even on this chilly February day. A signboard and cart have been positioned on the sidewalk. At the top of the board is the current name of the deli, Milant, but long-time customers remember when it was called Melange. Now it is almost lunchtime, and the board lists the daily specials, low-priced sandwiches with a cup of soup—but wait, the soup has been crossed out. Other handwritten offers are taped inside the glass of the door and window, chalked on a blackboard between the door and the window, stuck into the items on the shelves in the window, and taped to the window frame. Among the delicacies are fresh carrot juice, gyro strips, Dubliner and Blarney cheeses, brie from Normandy, cheddar from Australia, pistachio halva, baklava, raspberry rugelach, and Milano cookies. Nuts and pretzels fill the plastic containers on the cart. Soon the customers will form a line that extends clear out onto the sidewalk, here on 39th Street between Third and Lexington.

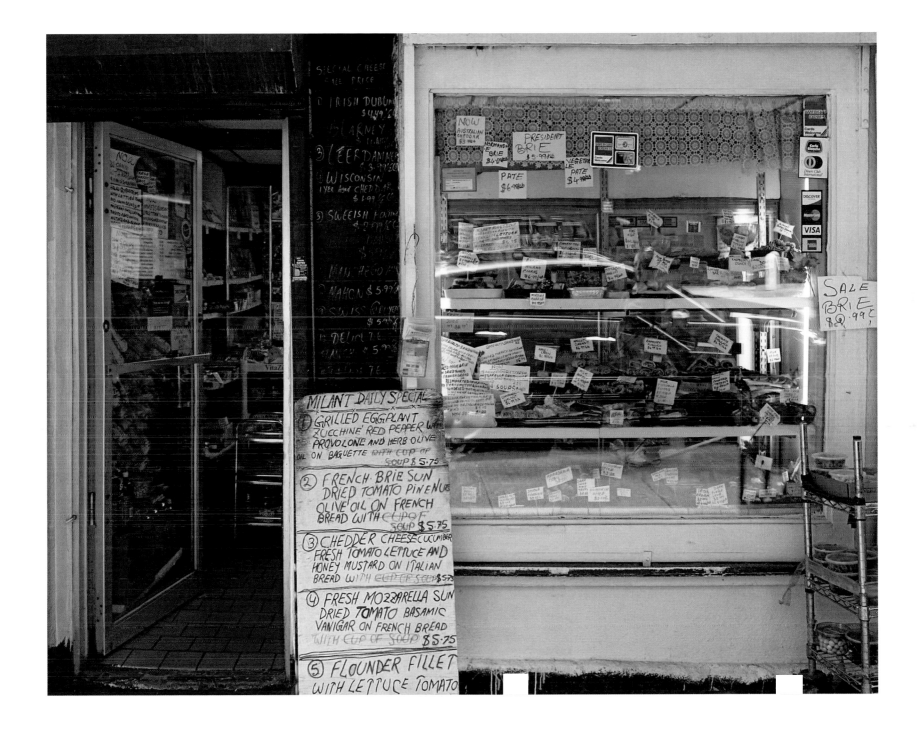

High Finance

The colors recall the Dutch Old Masters, but what awaits us on this summer day in 2009 is an exhibit of photographs, cataloged on the computer at left. Four hundred summers ago, Henry Hudson, an Englishman working for the Dutch East India Company, discovered an island whose inhabitants called it Manna-hata, "Place of Many Hills." To commemorate his discovery, four New York City photographers were invited to discover Amsterdam. They made "surprising images that reveal an unknown side of the Dutch capital," now on display in the corridors around this refurbished bank lobby. In the vaults below us, which now stand open, are historical images of what was once Nieuw Amsterdam. Above us, filling seven floors of former offices, are the archives of the City of Amsterdam. When the building opened in 1926, it housed the Netherlands Trading Society, successor to the Dutch East India Company. The architect, Karel de Bazel, died too soon to see the completion of his grandest work. For the exterior he chose a "brick expressionist" style, with alternating bands of red and yellow. Locally, the building has long been known by the name of a Dutch-Indonesian confection, De Spekkoek, "Layer Cake."

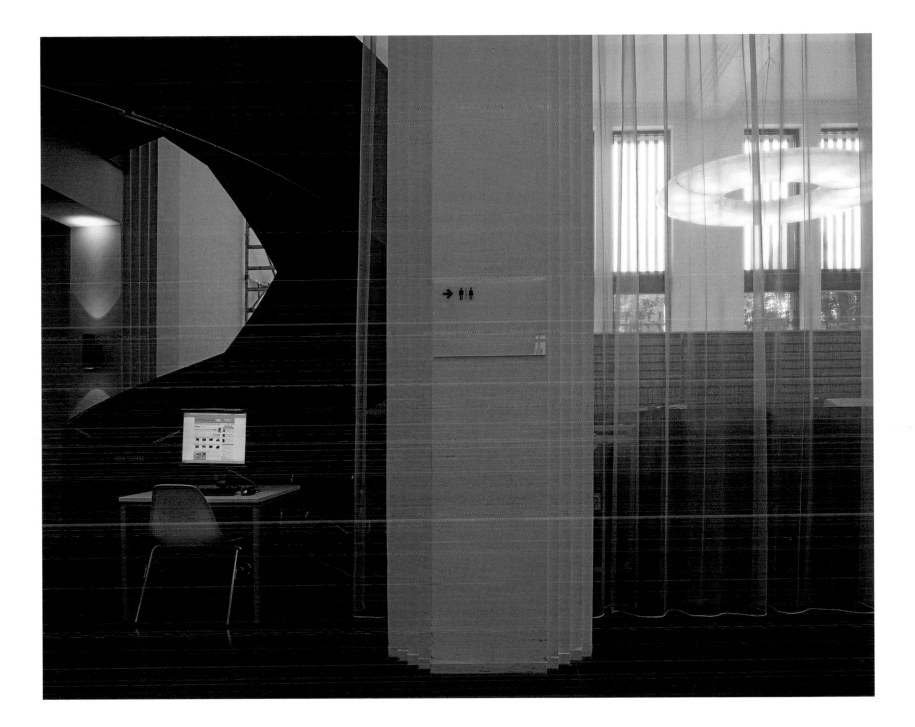

New Year on the Old Side

The Shun Cheong supermarket, at numbers 6 and 8 on Stormsteeg, is not open this early in the morning. Three posters in the windows invite the reader to find out what is "te koop" (for sale) by dialing the number of Henk Burger, the realtor who rents the apartments above the supermarket. The large red poster announces Chinese New Year celebrations that took place five months ago, on January 24–31, 2009. New Year's Day itself came with the new moon of January 26. At the center of the poster, in black and yellow, is the Ox, the zodiacal sign of the new year. The top poster in the door nearest the bicycle features the leading actors in a suspense series produced by BTV in Hong Kong. It goes by the title *Last One Standing* in English, but the Chinese title, 與敵同行, means "traveling with the enemy." On the right is Kevin Cheng in the role of Cheung Sing-Hei, who served ten years in prison for a crime he did not commit. On the left, half in shadow, is Roger Kwok in the role of Tong Lap-Yin, who gave false testimony at Hei's trial and became rich by cheating Hei out of his inheritance. Not shown is Yoyo Mung as Carmen, a reporter and former fiancé of Yin's who eventually meets Hei. The door with this poster may be the one that leads to the apartments upstairs. The neighborhood is the Oude Zijde, the "Old Side" of central Amsterdam.

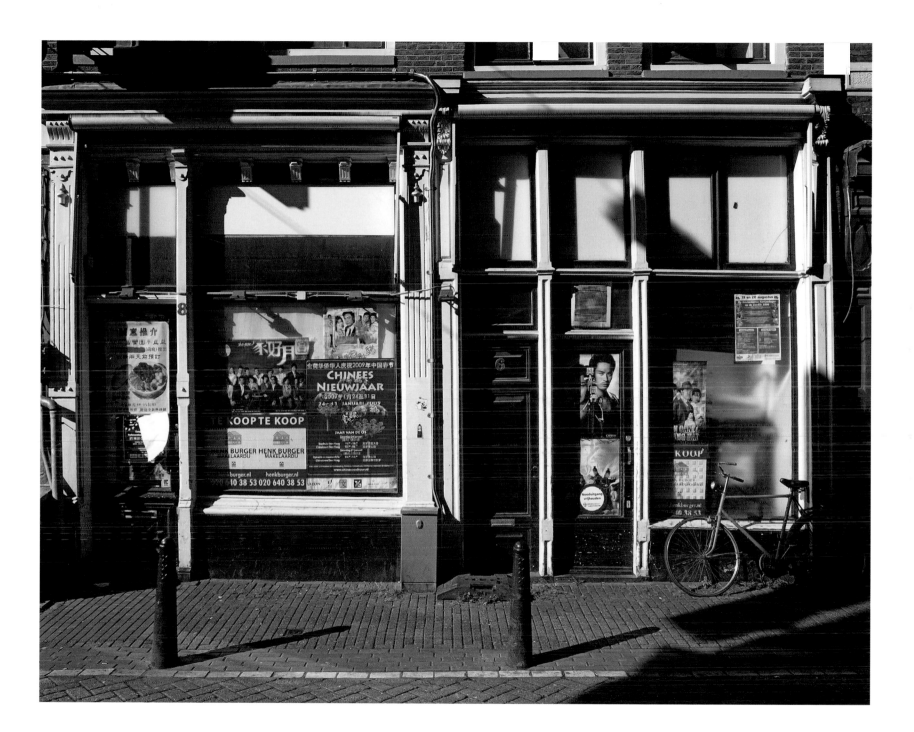

Heading West on Spring Street

At first glance the posters at left look like abstract art, but a closer look reveals profiled sneakers on a background of flowers. Vans Off the Wall sneakers and sweatshirts are sold in the same stores as Joel Tudor's skateboards and surfboards. To the right, the small print on the beetle-and-butterfly posters invites us to go online and design our own Nikes, decorating them with images of insects if we so choose. If we don't have the right coins to buy the *Post* or the *Times*, we can check the personals in the *New York Press*, look for a job in *The Employment Source Magazine*, or read a story in *The Onion* headlined "Cost of Living Now Outweighs Benefits." On the sidewalk between the bins for *USA Today* and the list of amazing classes offered by The Learning Annex is the cache of a homeless person. Among the online classes offered by the Annex are A Beginners Guide to Craps, Facial Rejuvenation, and How to Attract Your Soul Mate. The man pushing the stroller is headed west on Spring Street, about to reach the Avenue of the Americas.

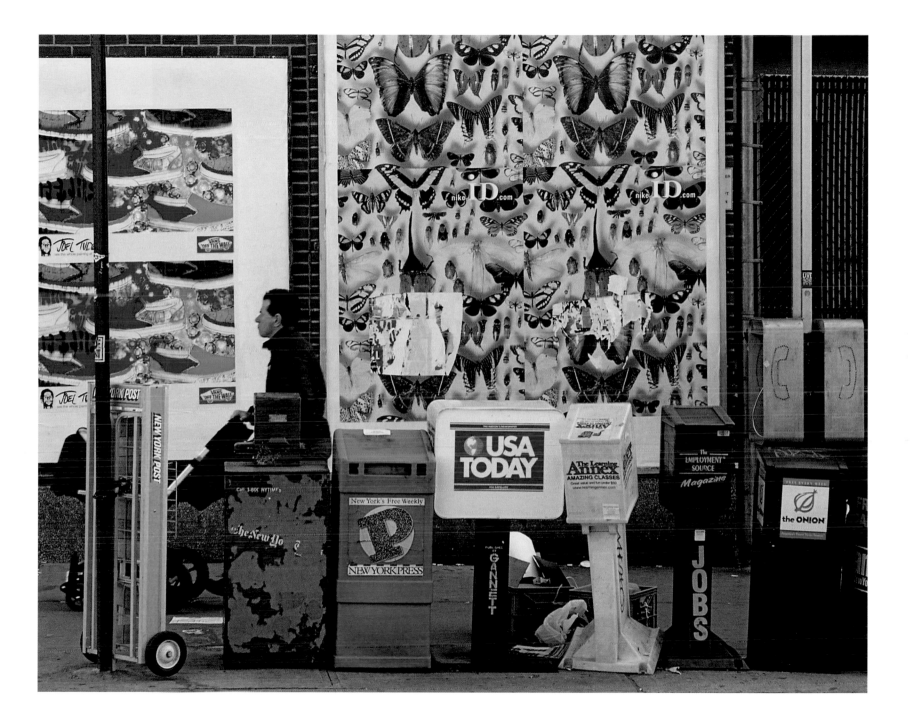

The Man in the Mural

If we turned and looked to our left, we would see a scene like the one painted on the left side of this shed, and if we turned in the opposite direction, we would see a scene like the one painted on the front side. We are standing on the shoulder of the highway that runs through both scenes. It's the only way in and out of the village of Villanueva, on a hill above the Pecos River in New Mexico. But the man portrayed in the painting can no longer greet us. Pedro Villanueva Gallegos, rancher, farmer, and storekeeper, was born here in 1912, the year New Mexico became a state, and he died in 2006. He served as a school board member and county commissioner, and he led the effort to establish a community water supply in Villanueva. The shed houses the well, with an electric meter for the pump on the left and a fire hydrant on the right. Another project that occupied Gallegos was the construction of a grotto dedicated to Nuestra Señora de Guadalupe. It sits on the horizon in the first scene, below the second cloud from the right but too far away to be visible.

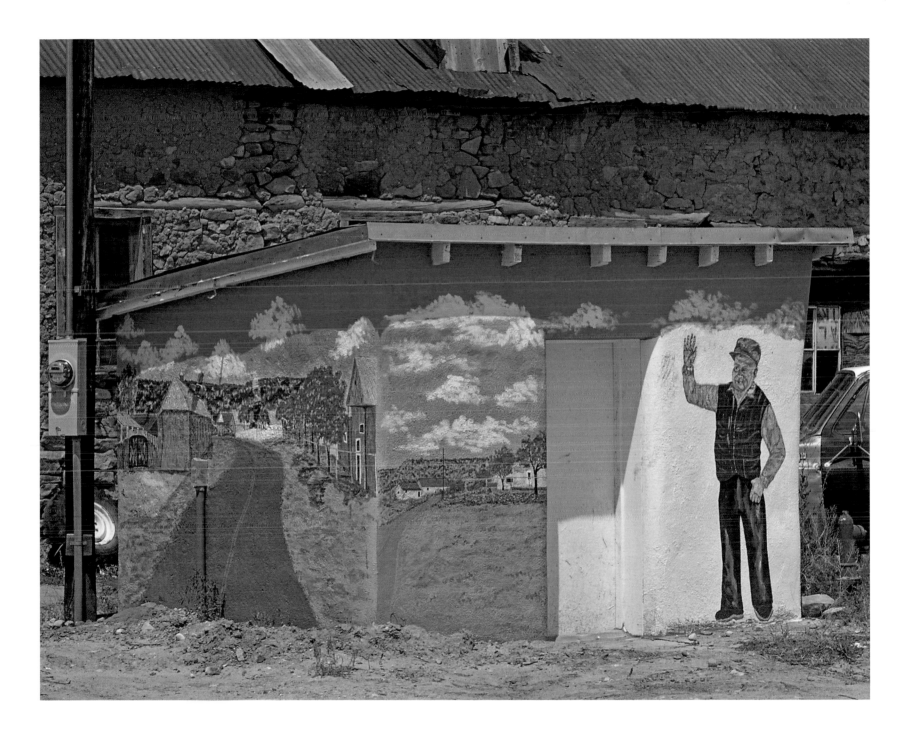

A History of Drought

The Santa Fe Railroad laid tracks through Mountainair, New Mexico in 1906, three years after the town was founded. For a time the town styled itself as "The Pinto Bean Capital of the World," but a drought arrived in 1946 and forced the return of farmland to ranching. The red light on top of this building, at the southwest corner of Broadway and Ripley Avenue, dates from the time when it housed the fire department. Next came a restaurant whose name, "The Brick House," almost shows through the white paint on the sign hanging over the sidewalk. After that came the Firehouse Restaurant, which closed in 2007, a year after a group of local artists painted the mural. A block away at the blinker light, U.S. Highway 60 meets State Highway 55, which leads north and south to the nearby ruins of Pueblo Indian villages, abandoned because of a drought during the seventeenth century. Straight ahead to the east, two hours away, is the grave of Billy the Kid. Two hours away in the opposite direction is the VLA (Very Large Array) of the National Radio Astronomy Observatory.

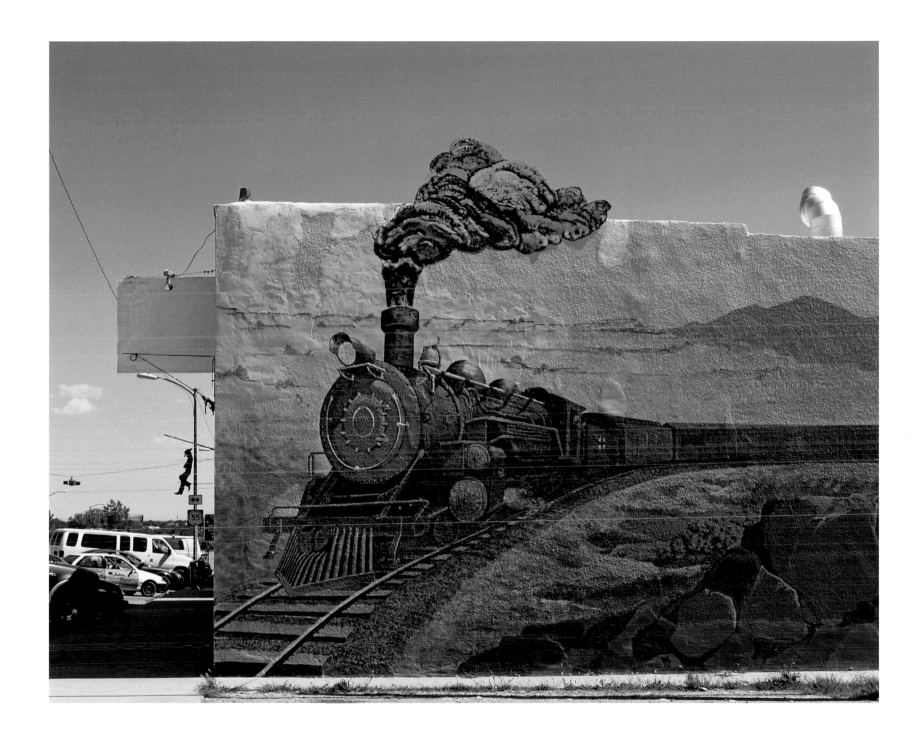

Homeless in a Painted City

Here, as if seen through wavy glass, are gray skyscrapers, a blue sky, and a white cloud—or perhaps we are looking at the scene through hot air that rises from the asphalt in the space between the curb and the wall. Either way, the muralist painted what he envisioned on straight courses of concrete blocks. The light blue arrows pointing upward at top left and top center seem to indicate that the orange object in the foreground is about to take off, with all its enormous size and weight. It resembles a Chinese character, rendered in the manner of the lettering that represents loud noises in cartoons, but it doesn't spell anything. The cobalt blue on the curb provides a picture frame, but the asphalt inside the frame has sprouted weeds in the time since the painting was done. Pages from a newspaper and a flattened cardboard box tell us that a homeless person spent the night here not long ago, using the space left free by the weeds. Fallen leaves from eucalyptus trees line the gutter. It is November, and we are standing in the middle of Berkeley Way, just off Shattuck Avenue in downtown Berkeley, California.

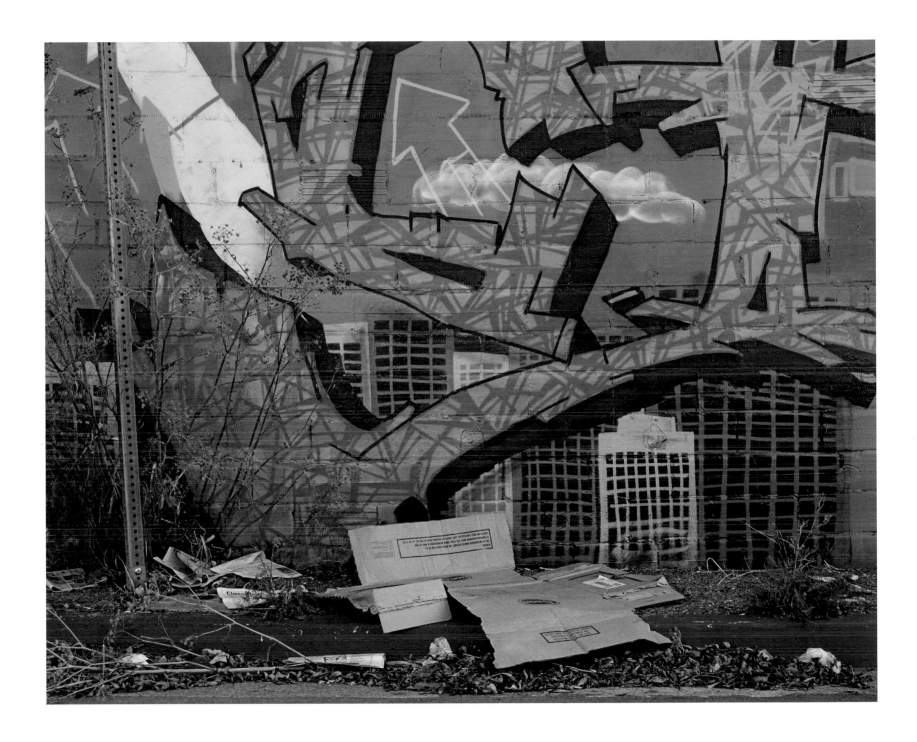

Five-Pronged Guitar Attack

Eleven days before this picture was taken, *Role Models* arrived in the theaters of the Bay Area. Five days after the picture was taken, the rock band Guns N' Roses released the album *Chinese Democracy*. And seventeen days after that, the City of Berkeley held the public meeting described by the legal notice stapled to the door between the posters. In *Role Models*, a pair of sales reps crashes a company truck while "on an energy drink-fueled bender," and a judge sentences them to serving time as Big Brothers for kids who give them "more than they plea-bargained for." *Chinese Democracy* features "a five-pronged guitar attack setting off explosions while a hard beat crunches away." The Berkeley meeting features an engineer who wants a zoning variance for the lot behind the door at 1908 Shattuck Avenue, where he plans to construct a building with one story too many and fifteen parking spaces too few. The door has no handle and the lot was cleared some time ago, but someone receives mail for 1908 in the box that sticks through the Guns N' Roses posters. Twenty years ago, a member of the International Double Reed Society sold wind instruments at this address. Still listed on websites are the Clarinet Cafe and the Iranian Cultural Foundation, but their phones have been disconnected.

Art in the Inner City

The store at Skindergade 41, across the street from here, sells professional and classic cameras. The store to the left, at number 38, sells Danish tables and chairs made of metal and plastic. To the right, at number 34, the windows are filled with antiquarian books and prints. Number 36 has been empty for some time, except for the abandoned computer monitor in the upper left window. A sticker warns us not to park our bicycle in front of the lower window. Posters announce the schedules of Søpavillonen, a bar and discotheque, and Rust, a nightclub. Artville, an international *kunstmesse*, "art fair," took place last year. John Legend, a rhythm and blues artist from Springfield, Ohio, will come to Copenhagen next month. Arriving next week is Anastacia, a Chicago artist known to her fans as the "Little Lady with the Big Voice." An exclamation point and asterisk add emphasis to the graffiti, but the messages carried by the letters are not meant for us. By the time a new tenant is ready to open the doors at number 36, no trace of the posters and graffiti will remain. Signboards naming The Old Barber Shop and bearing the picture of an anchor will invite us inside to have our skin tattooed and our flesh pierced.

Currently Playing in Clayton

On the day after a full moon in the middle of June, the Man in the Moon winks at us from the marquee of the Luna Theater. His features are outlined in neon, but empty sockets are all that remains of the neon that gave him rays and framed the signboards. The boards were meant to be lit from within, but the one on the side of the moon's closed eye is a hollow shell, and the other one has been fitted with a sheet of plywood whose white paint is peeling at the bottom. Floodlights mounted on overhanging rods once lit both boards, but now the sockets on the right are empty. When darkness comes, the plastic letters on the left will be lit from the front rather than the back, casting shadows as they do now, but if we could view the backwards J from behind, it would look the way it should, glowing red. The ticket booth and double doors seem to be in fine working order, and someone looks after the potted plants that flank the steps. Beneath the metal awning across the street, the photographer aims his camera across the trunk of a parked car. The red letters on the yellow sawhorses stand for "Town of Clayton." We are out on the High Plains, where the northeast corner of New Mexico meets Texas and Oklahoma.

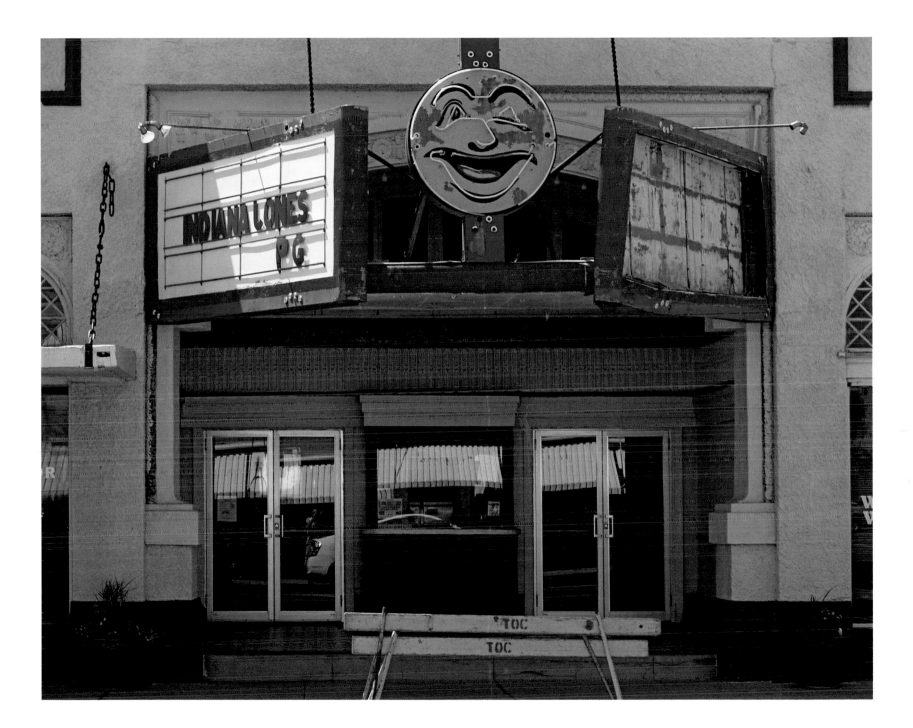

Hercules on the Waterfront

The telephone box says we are in Britain, the flowers say it is spring, the clock says the current time is 1:14, the rust stains and whale ribs tell us we are near the sea, and the quality of light speaks of seaborne clouds in the sky. Mounted between the two ribs is a carving that once graced the stern of a sailing ship. It features the bust of a man with a lion pelt over his left shoulder and a club to his right, broken off to the point where only one of its red knotholes remains. Together, the pelt and club tell us he is Hercules. On the ground, between the phone booth and the door below the clock, sits a water dish for a dog. A yellow sign in the window of the door cautions us that the area is covered by closed-circuit television. The small sign below the mail slot identifies someone within as the local agent of the Shipwrecked Fishermen & Mariners Royal Benevolent Society, but the temporary sign in the window to the right, below a stuffed clown, tells us the staff is on the pier. Whoever uses the room at upper right has decorated the window with a CD. No sign gives the name of the building, nor do numbers give its address. It sits on the landside of a curved pier that shelters a small harbor, and the locals know it as the Maritime Building. We are in Kent, in the town of Broadstairs, where Charles Dickens once resided in Bleak House. This is where the English Channel meets the North Sea.

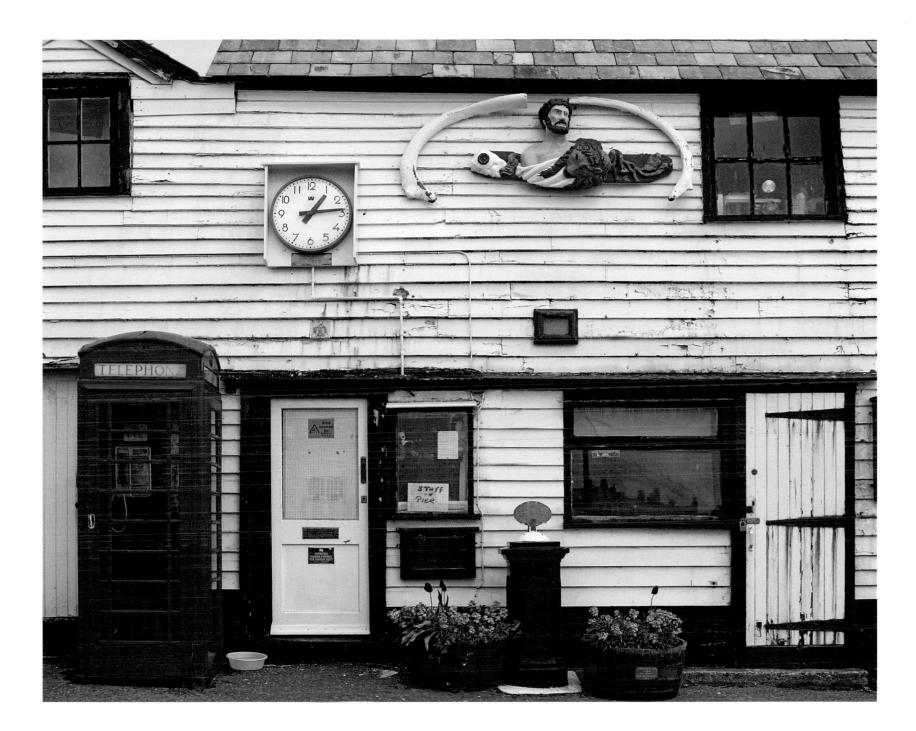

Astronauts on Tour

The transparent acrylic tops of these two tour boats keep passengers dry in wet weather. At the moment the boats are empty, moored side by side in a canal. Seen from this angle, their tops become convex mirrors for the buildings that line the street on the opposite side of the canal, beyond the parked bicycles. If we looked at the buildings directly, we would see that they stand twice as high as they are wide or even higher. The dark red bricks, large windows, and gables speak of seventeenth-century Amsterdam. We are looking across the Rokin, a canal that follows the former channel of the Amstel, the river that gave Amsterdam its name. The identical pair of gables belongs to the Hotel des Arts, which advertises rooms with exposed-beam ceilings. On the near side of the canal is the street called Oude Turfmarkt, "Old Turf Market," where peat was once sold for fuel. On July 30, 1988, when Queen Beatrix and her family made a surprise visit to the city on the occasion of her mother's birthday, they toured the canals in one of these boats. Among the other notable passengers of the past are Neil Armstrong and Buzz Aldrin, who had recently returned from the moon, and Mikhail Gorbachev, who had recently resigned as President of the Soviet Union.

Where the Valkyries Ride

This opera house stands on Dock Island in Copenhagen, directly across the harbor from Amalienborg Palace, the residence of Queen Margrethe II. Reflected in the fifth band of glass from the top is a row of palace windows with their awnings drawn up to admit the morning sun. The architect, Henning Larsen, had wanted nothing but horizontal bands of glass above the entrance level, but the donor, shipping magnate Maersk McKinney Møller, insisted on adding the strips of metal that alternate with the glass. A critic compared the result to the grille of a 1955 Pontiac, but it looks more like the 1958 model. Visible through the third band of glass from the bottom are three chandeliers designed for the foyer by Icelandic artist Olafur Eliasson. Below the middle one, two champagne bottles stand on a long bar. In front of the bar is a red bench, turned outward to offer a view of the palace. For the opening season in 2005, the Royal Danish Theatre produced Richard Wagner's *Die Walküre*, with Plácido Domingo in the role of Siegmund. Except for the blood-soaked gowns worn by the Valkyries, the costumes and stage sets were keyed to the 1950s, with evocations of the Cold War.

Seeking Remedies in Dreams

It was here in Epidauros that Apollo pulled his son Asklepios from the womb of Coronis. She was lying on her funeral pyre, having been shot with lightning arrows by Artemis, Apollo's twin sister. His spirit familiar, a white crow, had informed him that Coronis had been unfaithful, making love to a mortal named Ischys. Apollo was so angry with the crow for failing to peck out the eyes of his rival that he burnt the bird black. He took Asklepios north to Mt. Pelion and left him in the care of the centaur Chiron, who taught the boy the arts of healing. Beginning in the sixth century BCE, Epidauros drew pilgrims seeking cures. Most of the buildings have long since been reduced to the blocks of volcanic tuff that form their foundations, but three masons on the scaffolding at left center are using Pentelic marble to reconstruct the west portico of the Temple of Asklepios. His statue stood at the east end, holding a staff with a serpent wound around it. Beyond the temple is the *abaton*, the dormitory where patients sought dreams that would reveal their remedies. The stones in the middle ground at right belong to the Temple of Artemis. We stand here at the end of spring, and if we waited until after dark and turned to look at the stars behind us, we would see Corvus, the Crow. Coronis resides there when she is not in Hades.

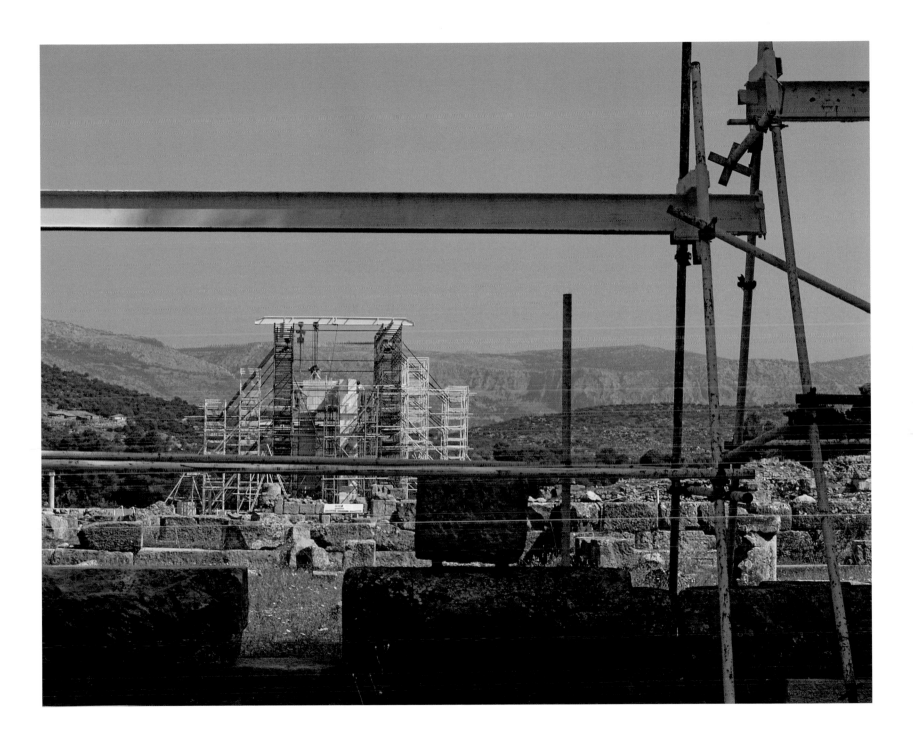

The Elk Return from the West

Solar cells supply the power for the prefabricated office of the newly-created Valles Caldera National Preserve, whose purpose is to balance environmental protection with the needs of a cattle ranch. The skulls with racks come from the surrounding valleys, where thousands of elk run in herds that compete with the cattle. Together, the valleys mark the site of a massive caldera, a system of magma chambers that exploded and collapsed more than a million years ago. Cracks along the rim of the caldera released lava that formed domes like the one on the horizon at left. Beginning 7,000 years ago, hunters camped along the edges of the domes and quarried weapons-grade obsidian. In 1860, Luis María Cabeza de Baca became the first rancher to claim ownership of the caldera. Sheep and cattle multiplied and all the elk were hunted out. During the twentieth century, loggers cut trees for pulp, miners extracted sulfur, drillers tapped into live steam, and developers dreamed of ski runs and race tracks. West of the caldera, the New Mexico Department of Game and Fish reintroduced elk. To the east, the Los Alamos Ranch School for boys became the home of the Manhattan Project. In cabins beyond the parked van, ranchers Franklin and Ethel Bond hosted Robert and Kitty Oppenheimer at Sunday brunches, and Gregory Peck befriended a widow living alone in the movie *Shootout*. Meanwhile, the elk were moving in from the west.

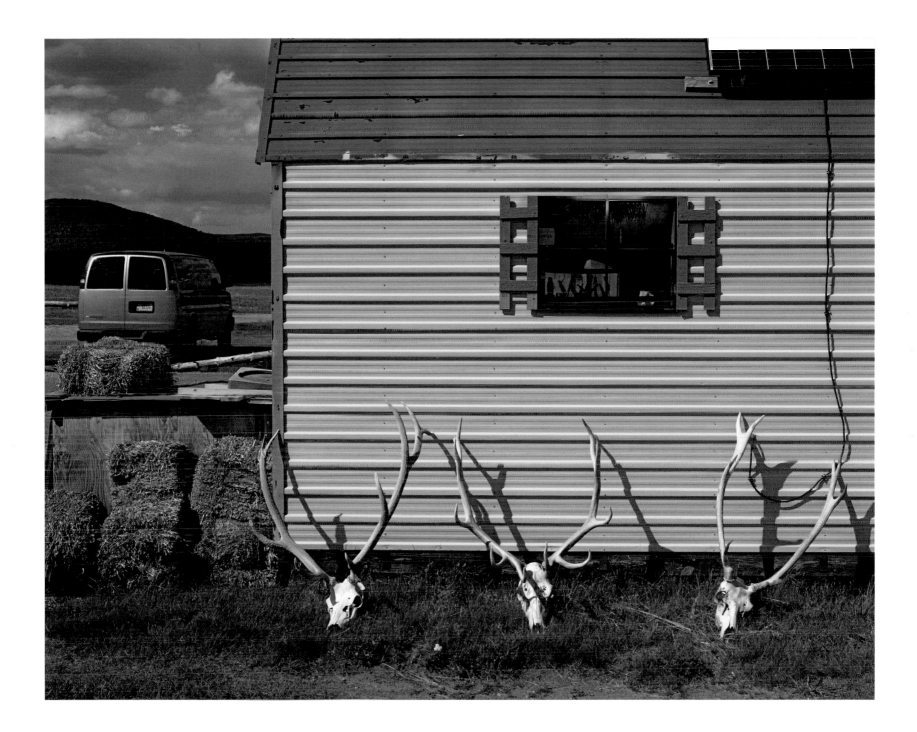

Juan de Oñate Rides Again

This conquistador has yet to mount his Andalusian stallion, and both of them have missing parts. But when all the pieces are put together, they will make the largest equestrian statue in the history of the world. The crest of the man's helmet will rise 36 feet above the hind hooves of his rearing horse. The sculptors are John Sherrill Houser, who grew up in the shadow of Mount Rushmore, and his son Ethan Taliesen Houser. The conquistador is Don Juan de Oñate, who was not born in Spain but in Zacatecas, halfway between the Valley of Mexico and El Paso. Philip II gave him orders to colonize northern New Mexico, and in 1598, he crossed the Rio Grande at El Paso on his way north. The statue will stand at the entrance to the El Paso International Airport, but the parts we see here are still on the loading dock at Shidoni Foundry in Tesuque, New Mexico, where the casting was done. The sculpture at right, with translucent disks of color, is by Troy Pillow, who uses wind and light as energy sources.

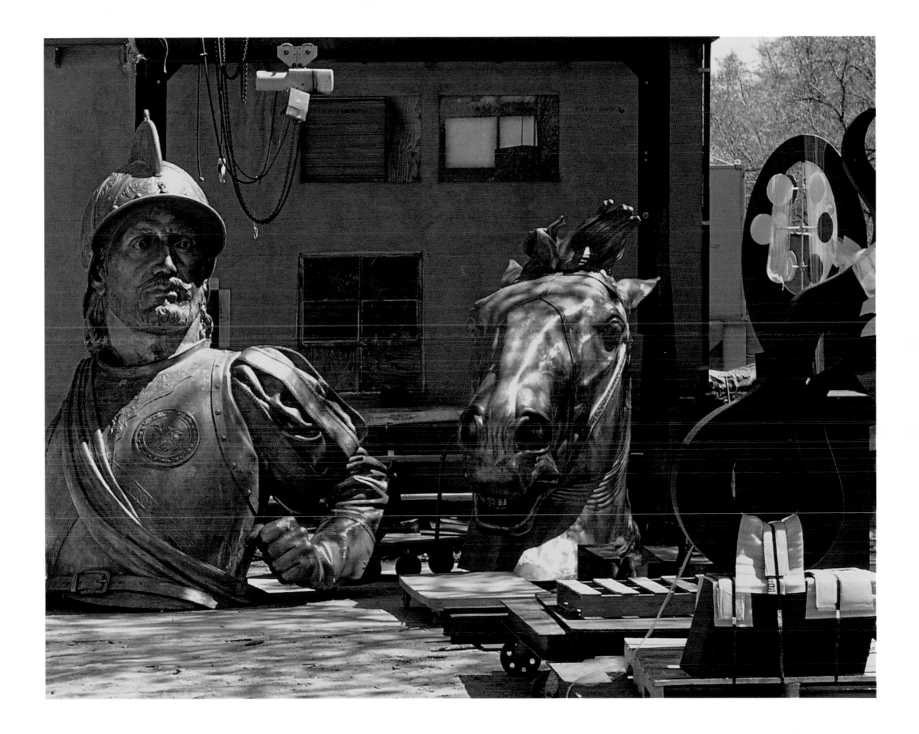

Cotton Growers Take Chances

Out here on the Great Plains, the silhouette of a barn and silo marks the horizon. The only sounds close by are made by this all-metal cotton gin, rattled by the west wind of a May afternoon. Behind us is U.S. Highway 56, the route of the Santa Fe Trail Auto Tour, and the tracks that run by on the other side of the gin are those of the Cimarron Valley Railroad. We are in Moscow, Kansas, where the wells that irrigate farms have been depleting ground water that dates from the Ice Age. Ten years ago, farmers began planting cotton, which requires much less water than corn or milo. Expecting an explosion in cotton production, they formed a co-op and built the gin in 2002. The cotton harvest hit a peak in 2004, but since then it has fallen off. One year brought a drought and another brought a hailstorm. Meanwhile, an increase in corn prices made cotton less attractive as a crop. Without enough cotton, a gin can only run at a loss, and the future of this one is uncertain. All of the electrical control panels have been disconnected and moved outside. One of them, the size of a refrigerator, sits in front of the railroad tracks. Perhaps there are plans to replace the panels with upgrades before the November harvest, or perhaps the future can be read from the golden grains of milo the wind has picked up from a bin on the opposite side of the tracks and deposited on the pavement in front of the gin.

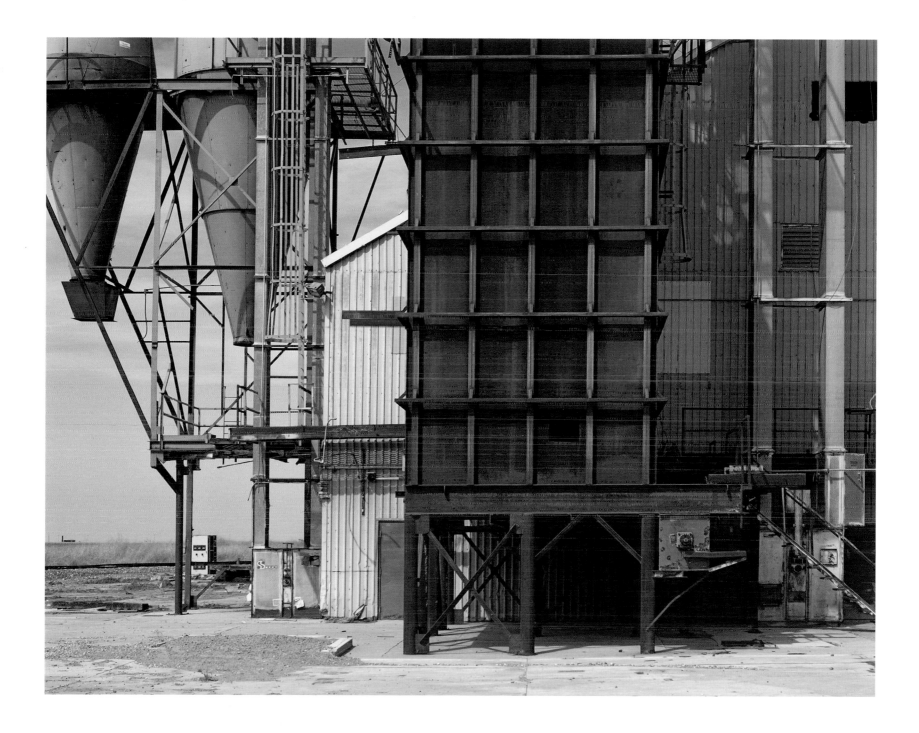

Signs in the East Harbor

Italian architect Renzo Piano designed the ship-shaped building covered with copper. Completed in 1997, it houses Amsterdam's science museum, whose name, NEMO, is spelled in yellow letters visible beyond the bleachers on the barge at left. The planners were aware that *nemo* means "no one" in Latin, and they intended an allusion to Jules Verne's Captain Nemo, commander of the submarine *Nautilus*. To the right of the yellow letters are three St. Andrew's crosses like the ones on Amsterdam's coat of arms, but instead of being white on a black background, they are red with empty space behind them. On the barge to the right sits a wooden crate bearing graffiti, and if we interpret the lettering as the web address hergen.nl, it will open a site offering a large selection of gaily painted push brooms, some of them in children's sizes. The lettering on the metal container to the right advertises a Rijksmuseum exhibit that was taken down three years ago, commemorating the 400th anniversary of Rembrandt's birth in 1606. Moored between the barges and NEMO is a replica of the East Indiaman *Amsterdam*, built by volunteers and completed in 1990. The original *Amsterdam* set sail on its maiden voyage in 1749, bound for Java, but was wrecked by a storm in the English Channel. Just west of Hastings, in East Sussex, the remains are visible at low tide.

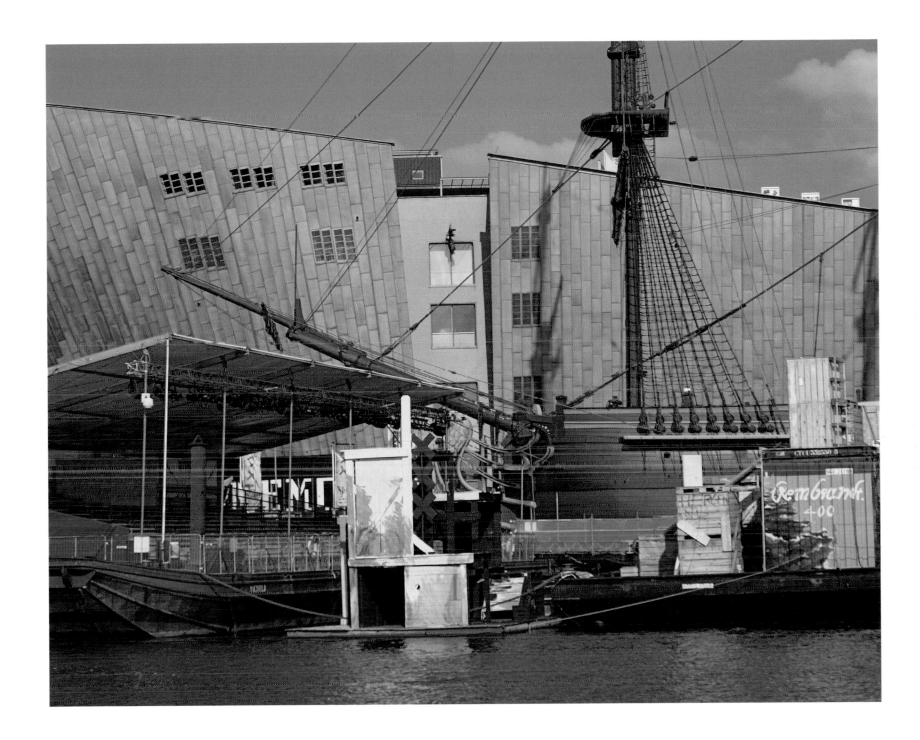

Seeking Leisure

Hundreds of tongue-and-groove structures like these line the gravel beach of Herne Bay, a town on the Thames Estuary in Kent. They are properly called "tea cottages," but some people call them "beach huts." Modest though they are, they go for a high price on the rare occasions when they come up for sale. Whether or not the owners furnish them with what they need to make tea, they can change in and out of their bathing suits, get in out of the wind, or sit on the steps. On this chilly April weekday, all the doors are padlocked. Above the cottages, lining the Western Esplanade, are substantial houses with a view of an offshore wind farm. Nearly everything in Herne Bay was built after 1833, when Londoners seeking leisure began to arrive by rail.

In the Valley of the Rainbow

Later today, wedding guests will fill these folding chairs in front of the Glen Iris Inn. The bride and groom will stand with their backs to the brink of a gorge, facing the inn. From behind and below them, the Middle Falls of the Genesee River will send up a roar and a mist. Sometimes the guests will look at the couple and sometimes at the mist, tuning into the words of the minister at some moments and losing themselves in the roar at others. The inn began as a house, built by Alva Palmer for Michael Smith in 1828. It was purchased and remodeled by William Pryor Letchworth in 1859, the year before the mansion built by George Washington was purchased by the Mount Vernon Ladies' Association. Letchworth followed the model of Mount Vernon in building the two-story porch, but he stopped short of replacing the siding with blocks of wood made to look like rough-cut stone. Having seen a rainbow in the spray of the Middle Falls, he named the place Glen Iris, combining the Scottish word for "valley" with the Greek word for "rainbow." The original Seneca name, *Andekagakwa*, means "place where the sun lingers." Only this part of the valley runs east-west, receiving sunlight all day long. A few years before his death in 1910, Letchworth gave the house and its land to the people of New York for the creation of a state park. The inn opens each year on Good Friday and closes on Halloween.

Billy the Kid on Location

Since 1918, the ground floor of 13 First Street in Cerrillos, New Mexico, has been the site of the Simoni Store. The porch and balcony were constructed by Disney Studios for *The Nine Lives of Elfego Baca*, a family-oriented Western about a peace-loving county sheriff, serialized on television in 1958. For the 1988 film *Young Guns*, starring Emilio Estevez as Billy the Kid, 13 First Street became the Wortley Hotel. As the sign over the door testifies, the cast and crew were grateful to their local hosts. The real Wortley Hotel, whose original owner was Sheriff Pat Garrett, is located two hundred miles away in Lincoln, New Mexico. In 1881, while U.S. Marshall Bob Ollinger was eating lunch there, a jailbreak occurred at the Lincoln County Court House. He dropped his fork and rushed to the scene, only to have the real Billy the Kid say, "Hi Bob," and let him have it with both barrels. Cerrillos, meanwhile, was enjoying a boom brought on by the discovery of gold in the nearby hills, soon followed by the arrival of the Atchison, Topeka & Santa Fe Railroad. More than a thousand mining claims were filed within the space of a few years, but none of them is the site of an active operation today. When Amtrak's Southwest Chief is on schedule, the Chicago-bound train passes through town at 1:35 p.m., followed an hour later by the train bound for Los Angeles. They don't even slow down.

Downtown Revitalization

In 1823, two years before the Erie Canal was open all the way from Albany to Buffalo, Ebenezer Mix surveyed a town site at the place where an aqueduct carried the canal over Oak Orchard Creek, a potential source for waterpower. He gave the town the name Medina, which rhymes with Dinah when present-day townspeople pronounce it. We are looking east across Medina's Main Street, almost alone on this Saturday afternoon in 2010. The original buildings were wooden, but a disastrous fire in 1866 led to their replacement with structures like these, made of stone and brick. The red paint, applied a year or so ago, has the hue of sandstone quarried just outside Medina, but the painter greatly increased the saturation. Most of the local sandstone was loaded on barges bound for New York City, where it went into the construction of those countless townhouses known as "brownstones." If we walk two blocks to the right and then turn west for another two, we will find ourselves at the Medina Railroad Museum, featuring the nation's longest HO-scale model railroad. In the miniature towns along the layout, the business districts are composed of buildings that look a lot like these.

Relics and Remedies

It is late February in Georgetown, two days past Washington's birthday, but a flag is still on display, sticking out of the upstairs window to the left of the trunk of the sycamore tree. Even on the sunny side of P Street, traces remain from the storm that struck almost three weeks ago, the storm christened "Snowmageddon" by President Obama. Sands of Time, the shop on the left, will not open until 11:00, two hours from now. It offers "exquisite, rare, collectible" antiquities of Greek, Roman, Egyptian, and Levantine origin. On the right, Morgan's Pharmacy is already open, but unlike chain stores, it closes at 6:00 p.m. on weekdays and has no hours at all on weekends. Herbal and homeopathic remedies are available at Morgan's, and a rack of tasteful greeting cards is visible through the window panes on the right. The store is listed in the *Not for Tourists* guidebook, and a local newsletter describes it as the kind of place favored by "retired Georgetown matrons." At first glance there would seem to be parking spaces, but that is a dangerous illusion. Washington is the kind of city where having your car towed is a real possibility.

Hamlet Questions Horatio

When this castle was completed in 1585, it was the largest in Europe. The architects were brought here from Antwerp, hired by Frederik II of Denmark to design a Renaissance replacement for a medieval castle built by Erik of Pomerania. Outside these walls is the Øresund, the narrow strait that connects the North Sea with the Baltic. On the landside is the town of Helsingør, better known by its English name. Says Hamlet to Horatio, "But what is your affair in Elsinore? / We'll teach you to drink deep ere you depart." If this had been some other summer, we might have heard Horatio describing the ghost of Hamlet's father in the courtyard outside these very windows, below the aluminum scaffolding that holds the stage lights. Recently, however, classical productions of *Hamlet* have given way to experimental versions, including *Hamlet Without Words*. The main attraction at this year's festival was *The Prince's Revenge*, performed by the Peking Opera Theatre of Shanghai.

Temple, Palace, and Harem

Fine white marble, yellowed with age, calls classical Greece to mind, and this is Pentelic marble, quarried near Athens, with a single course of gray limestone visible at upper right. We are standing in the east portico of an empty temple, looking all the way through to the west wall and the sky of a morning in May. The surfaces covered with chisel marks are the backsides of stones whose smooth sides face the other way. Somewhere in the bedrock enclosed by the temple was a saltwater cistern, created when Poseidon tossed a trident at the Acropolis. The southwest corner rests on the burial mound of the founder of Athens, Kekrops, whose spirit inhabited a snake that lived beneath the temple. Priestesses fed the snake with honey cakes and studied its moods for omens. Today the temple is known as the Erechtheion, but it once had a double identity. One altar was devoted to Athena Polias and the other to Erechtheus, who was born of the earth and raised by her. He was an early king of Athens, residing in a palace on the Acropolis and dying here. The temple was built in 421–407 BCE. In its later life it served as a church, a Frankish palace, and a Turkish harem. A partial restoration was carried out in 1909–1917. In theory, Erechtheus received his offerings at the west wall, while Athena Polias received hers closer to where we stand in the portico, barred from setting foot inside their temple.

Famine Comes to Las Humanas

The holes in this wall once held beams that supported the loft in the granary of a Franciscan friary. On the sunlit side of the wall, saltbush and cholla cactus fill a courtyard that was once surrounded by stables and pens. Attached to the friary is an unfinished church whose intended patron was San Buenaventura. Beyond the church are the ruins of a village whose name in the local language was Cueloce. Spaniards called it Las Humanas, after a tribe whose members came there to trade. The architect for the church and friary was Diego de Santander, sent from Santa Fe in 1659. By that time the village was 800 hundred years old, but it lasted only twelve years more. In 1661, the friar, following orders from his superiors, oversaw the destruction of the local kivas, meeting places for medicine societies. A drought and famine followed, and the survivors abandoned their homes in 1671. During the nineteenth century, Anglo Americans gave the ruins the name of a place long sought by Spanish explorers but never found: Gran Quivira. The mortar between the pieces of limestone dates from the twentieth century, when the National Park Service acted to prevent the ruins from falling any further into ruin.

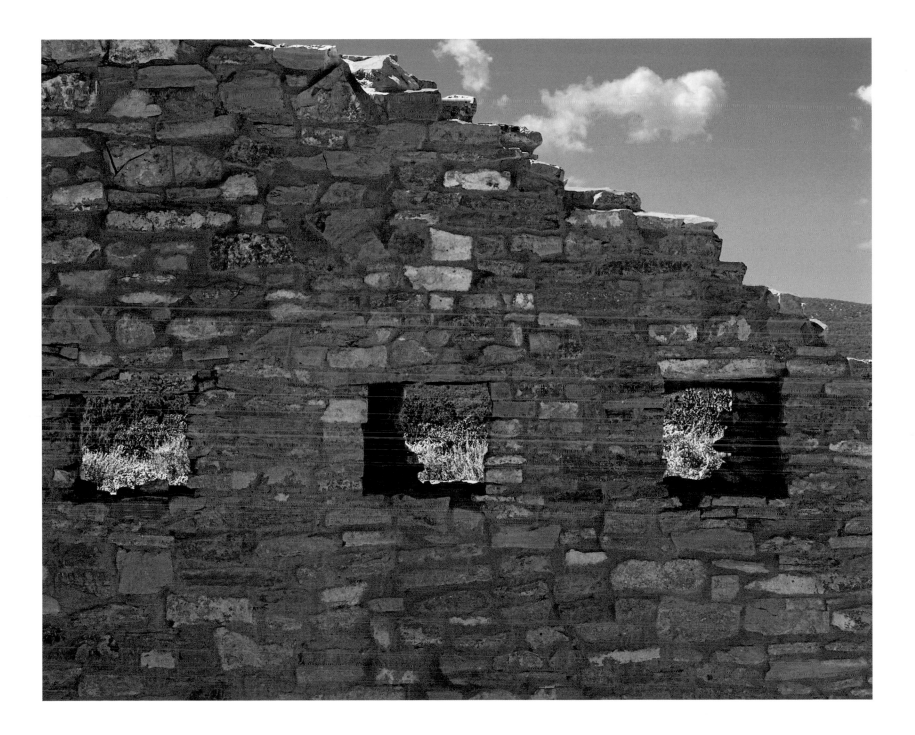

After 200 Million Years

The gray mountain far away is Triassic, created by a flow of basalt that emerged from the earth more than 200 million years ago. The sandstone cliff closer by is Cretaceous, formed by deposits that were laid down on the shore of a sea more than 60 million years ago. In the foreground, the earth belongs to a deep layer of soft Tertiary sediment, laid down as recently as two million years ago. Basalt and sandstone are combined in the retaining wall at right, and pieces of sandstone pave the dooryard and hold down the low end of the Coca-Cola sign. The adobe bricks at right were made from the sediment. Nearby is the Río Puerco, the "Dirty River" that has taken this New Mexico valley through several cycles of arroyo cutting and filling over the last few thousand years. In the 1880s, when the cycle was about to shift toward erosion, cattle ranchers and irrigation farmers founded a village on this site. First it was known as Ojo del Padre, after a nearby spring, and later as Guadalupe. Overgrazing hastened the erosion, and by the 1940s, the river had cut a deep gulch that made irrigation impossible. A few cowhands stayed in the area, and one of them salvaged materials from abandoned houses to build this seasonal shelter. It had no electricity and no woodstove, but the windows were screened and the privy was right outside the front door.

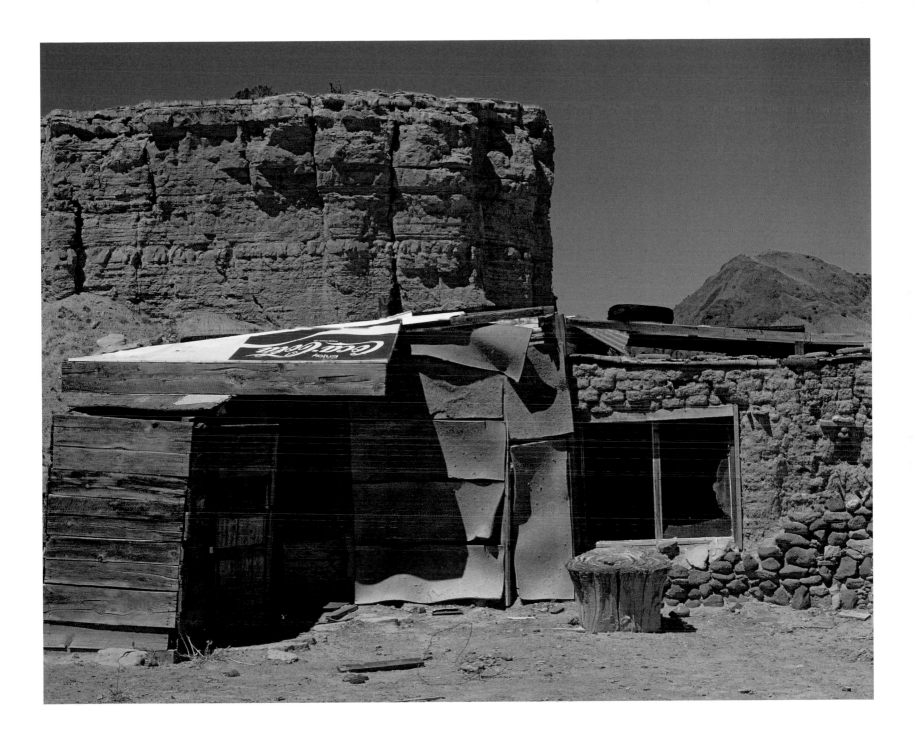

On the Edge of Memory

Freight trains still travel the line that runs through Clayton, New Mexico, connecting Denver and Fort Worth, but they seldom stop. Sunlight enters this trackside warehouse through the roof, but the doorway has been closed with four long pieces of sheet metal, set on edge. Once they were joined end-to-end, forming the sides of a circular cattle tank. The Butter-Nut coffee can is collectible, currently selling for as much as $30.00 on the web. It sits on the platform of a Fairbanks scale mounted on wheels, manufactured in the late nineteenth or early twentieth century in St. Johnsbury, Vermont. To the right is a pair of wooden Doric columns that once graced a bar. Lying across the foreground is the screw from a grain augur. The screw rotated inside a conduit with one end raised higher than the other, picking up harvested grain at the low end, moving it up through the length of the conduit, and dropping it through a hole in the roof of a grain bin. It is difficult to say whether the coffee can, scale, columns, and screw still occupy a place in the minds of those who stored them here or whether they have passed into the realm of abandoned objects. Visible through the gaps in the sheet metal are the bricks and nicely pointed mortar of the Clayton City Hall.

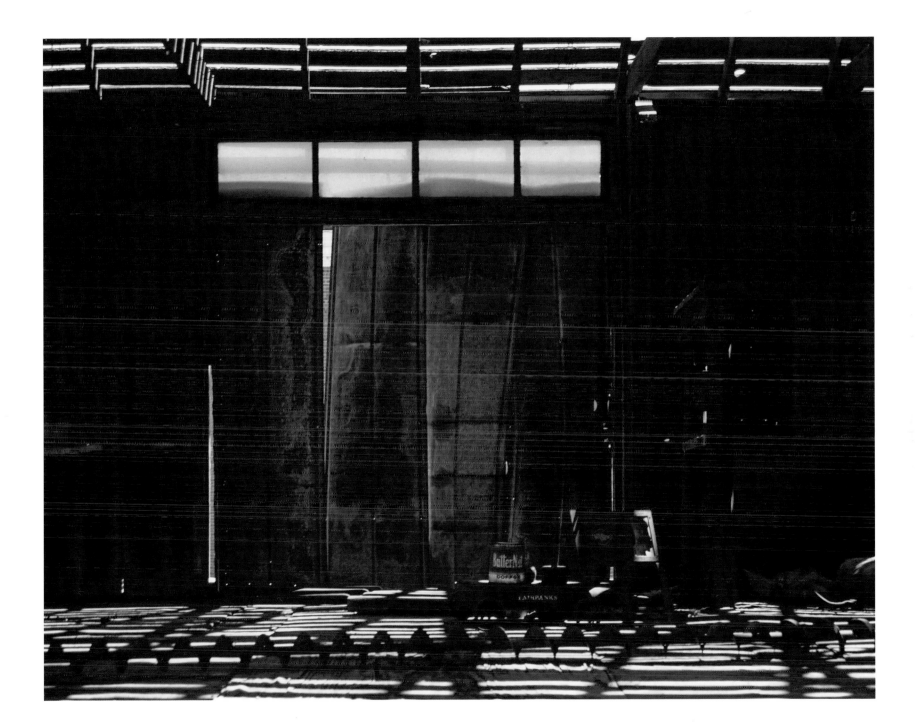

Photographs on a Higher Level

The windows look across Keizersgracht, the "Emperor's Canal," from the third floor of FOAM, the FOtografiemuseum AMsterdam. As described by Benthem Crouwel Architects, the 2002 makeover of the building retains "the original ambience and spaciousness," providing "no-frills exhibition spaces" in which "the visitor's attention focuses automatically on the photographs." The photographs between the windows are lost in the glare, but they are hanging in a space that was designed to serve as a library, not a gallery. We are meant to seat ourselves at the table and focus on the photographs in the double-page spreads of large-format books. The problem is that we have not made an appointment, so the overhead lights have not been turned on and there is no one to ascend the helical stairway to the stacks and bring our selections down to us. Whether or not the architects did so intentionally, they chose a helix that twists in the opposite direction from the DNA molecule and in the opposite direction from a proper ascent toward a sacred space. The benefit of going upward is canceled by having to go leftward, and the benefit of going rightward on the return is canceled by having to go downward. It would be just as well to let someone else get the books, some other day.

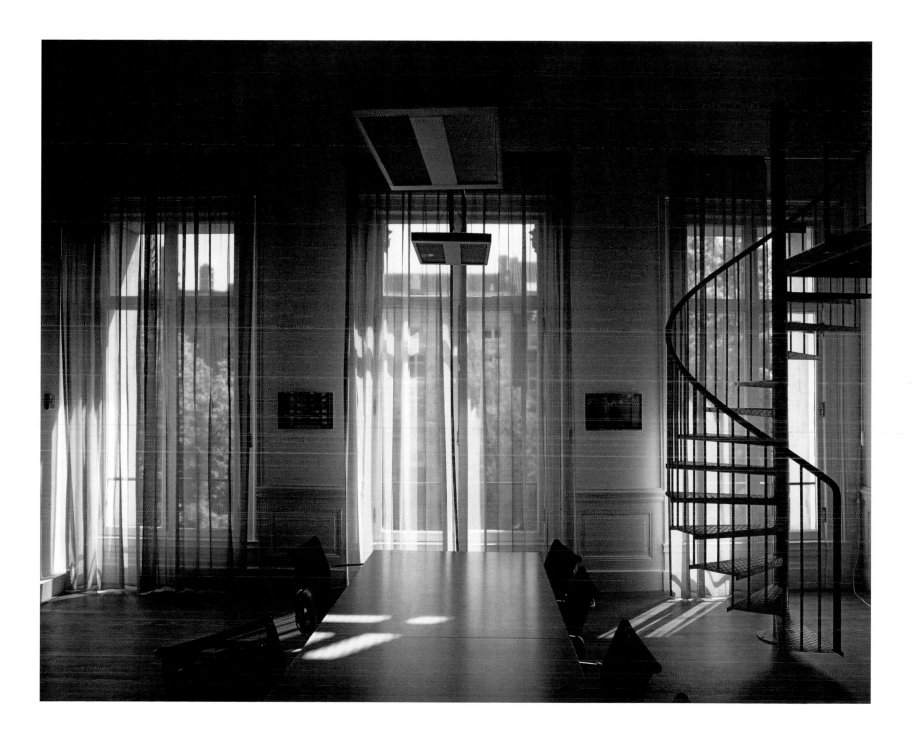

Beyond the French Quarter

When Napoleon sold Louisiana to the United States in 1803, New Orleans began to grow. Speakers of French called the original city the Vieux Carré, and speakers of English called it the French Quarter. In 1805, on the downriver side of the Quarter, Bernard Xavier Philippe de Marigny de Mandeville turned his plantation into a subdivision, the Faubourg Marigny. The houses in this photograph stand one block from the Quarter and another block from the first lot he sold. In 1809, he offered lots with no down payment to whites and freemen of color who were fleeing the turmoil that followed Haitian independence. Until the middle of the nineteenth century, we would have heard nothing but French on a walk around this neighborhood, but then came German and Irish-accented English. In 1914, a sewer system made indoor toilets possible. The 1970s brought an influx of young professionals who organized the Faubourg Marigny Improvement Association. These two houses, on Frenchmen Street near the corner of Decatur, were converted into a hotel whose air-conditioned rooms are furnished with Victorian antiques.

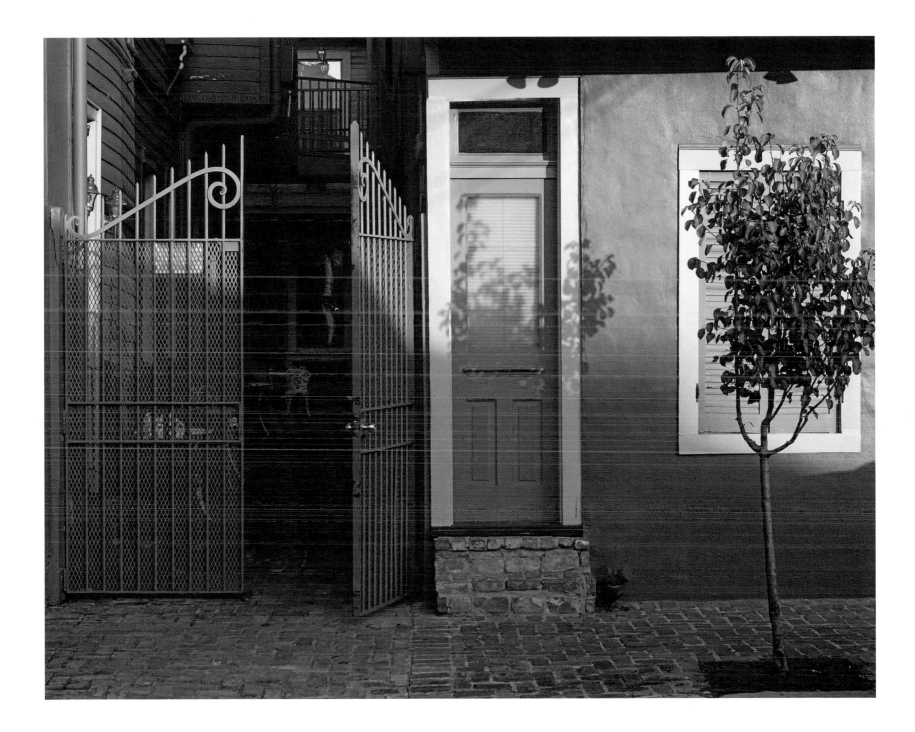

Do Not Dig a Grave by Hand

A fresh layer of lime plaster, colored to make it look like adobe, softens the rubble masonry of this church. The window has been fitted with a new frame, but the tilt of the opening has been left intact. A new tin roof protects the top of the wall, and a new cement walk protects the foot. Almost nothing remains of the weeds that once grew in the churchyard, thanks to an herbicide and a layer of fine gravel. The tombstones, cast-iron fences, and praying angel, all of which are out of plumb, have been left undisturbed. A sign posted at the boundary of the churchyard warns us not to plant trees or shrubs, build a fence around a plot, or dig a grave by hand. We are in the village of Punta de Agua, on the east side of the Manzano Mountains of New Mexico. The church, built in 1878, is dedicated to San Vicente de Paul, known as the Father of the Poor. In 1991, federal drug enforcement officials conducted a raid on Punta de Agua, using armored personnel carriers and surveillance helicopters provided by the National Guard, but they failed to find any drugs.

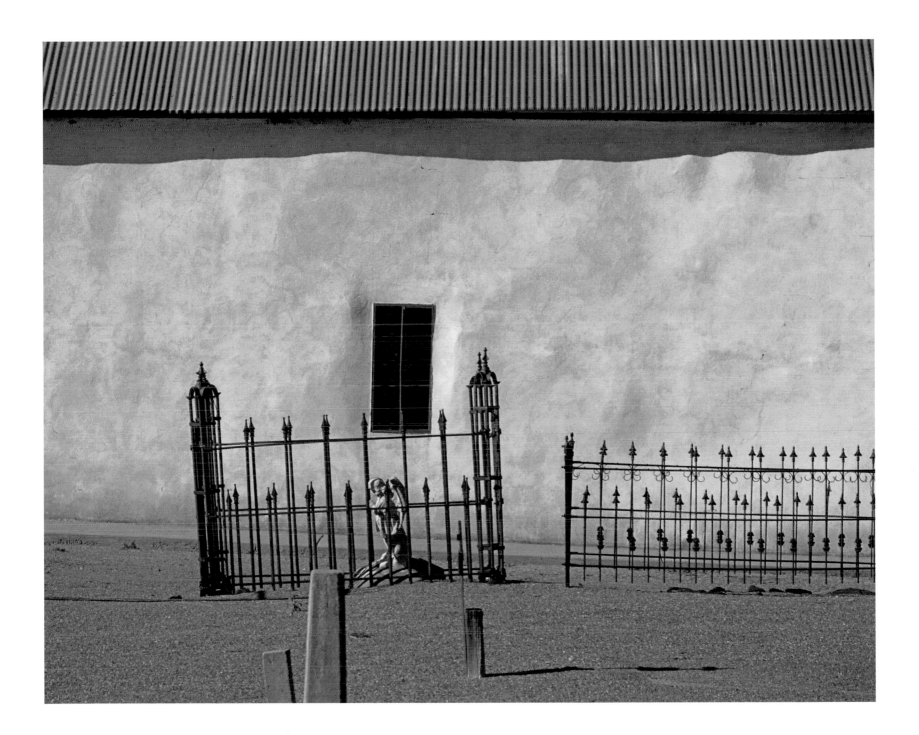

Monument to Penitence

These adobe walls enclose the nave of the church of Santa Rosa de Lima, curving inward to form an apse at the west end (to the left). In 1744, when the church was built, it served a village called La Puente. The river visible beyond the walls is the Chama, flowing eastward to join the Rio Grande. Three miles upstream is the village of Abiquiu, famous in the eighteenth century for witches who poisoned the parish priest and in the twentieth for the long residency of Georgia O'Keeffe. Abiquiu was founded in 1754, on a land grant given to 34 families of Christian Indians who came from nations that ranged from Hopi and Navajo in the west to Pawnee and Kiowa in the east. They built their houses on the ruins of a Tewa village that had been abandoned two hundred years earlier. Santo Tomás was their official patron, but they held Santa Rosa, notable for her penitence, in equal regard, and their descendants continue to do so. Her church was abandoned in 1767, but when her day comes, the Hermanos Penitentes of Abiquiu lead a procession into the ruins. Some years ago, they found a way to shelter the celebrants. They added new courses of adobe bricks to the near wall and topped it with window frames, permitting them to bridge the nave with beams. Their work provides no shelter on this morning in March, but when they prepare for the Saturday closest to August 23, they will spread a tarpaulin over the beams.

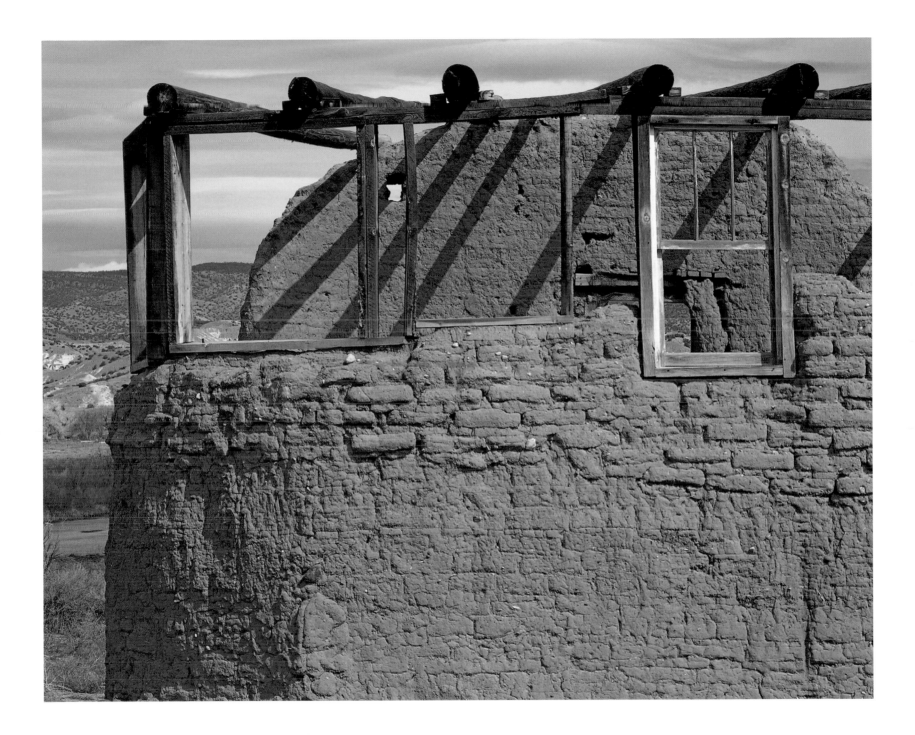

Nuns No Longer Sing Here

Blue and green light comes in from a misty morning in the highlands of Guatemala. Yellow light comes down from tungsten bulbs in what was once the choir loft of the church of Nuestra Señora del Pilar de Zaragoza, in the city of Santiago de los Caballeros de Guatemala. Diego de Porres was the architect for the church and the adjoining convent, commissioned for the order of Capuchin nuns and completed in 1736. Unlike other orders, the Capuchins did not require dowry payments from novices. They remained in their quarters after the earthquake of 1751, but the earthquake of 1773, which left much of the city in ruins, was too much for them. Along with the colonial government of Guatemala, they moved to Nueva Guatemala de la Asunción, the present Guatemala City. They took their doors, paintings, sculptures, furniture, and cast-iron railings with them, leaving behind bare rooms, some of them open to the sky. Since 1972, the usable spaces, including this choir loft, have been occupied by the Consejo Nacional para la Protección de la Antigua Guatemala, devoted to the conservation of historical monuments. For the people who work here, dust is a constant problem.

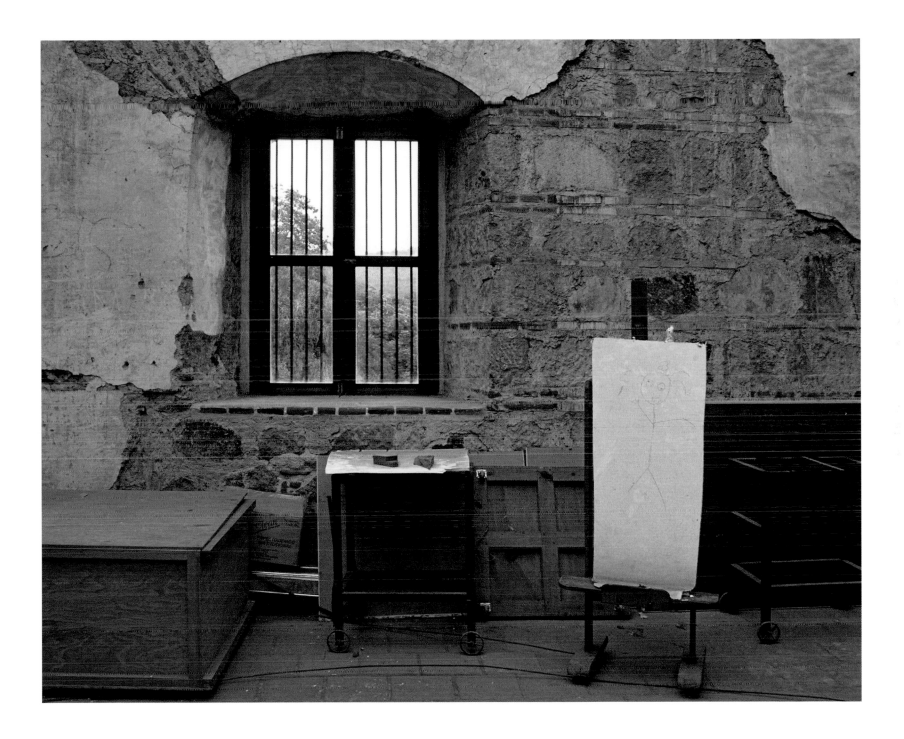

Houses in Hardened Ash

Here are the traces of a few rooms in a structure that was three stories high and half a mile long, housing an entire village in Frijoles Canyon, New Mexico. The masonry that formed the front walls has fallen away, exposing back walls that were cut into a cliff of hardened volcanic ash and doorways that lead to interior rooms. The builders chose a cliff that faces southwest, reducing the need for winter firewood. Running above and below the rooms are small round holes that served as sockets for roof and floor beams. Someone standing on the roof of the middle room carved petroglyphs in the cliff, just above the overhang. Most of the marks are hard to interpret, but the sharpest ones form the profile of a bird facing right. The ceiling of the middle room was blackened by smoke from a fireplace, but the walls were repeatedly coated with plaster to keep soot off the clothing of the residents. Fragments of roof beams found in nearby structures yielded tree ring dates running from 1383 to 1525. Shortly after the last date, all the residents of the canyon moved downstream into the valley of the Rio Grande. Their descendants live today in the villages of Cochiti and Kewa. The nest of twigs in the dark hollow at the bottom of the picture was built by pack rats.

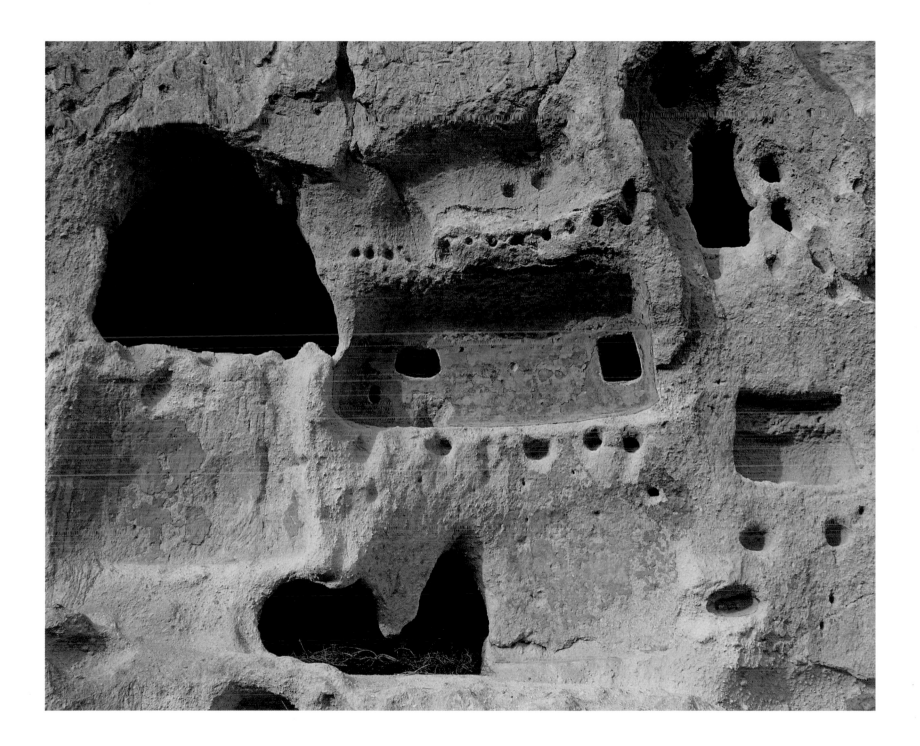

Rock & Roll Stops the Traffic

The flag says "California Republic," the skyline says San Francisco, and the blue sky says summer. We are standing in Justin Herman Plaza, with the ghost of a demolished freeway behind us. In the distance, from left to right, are the Hyatt Regency hotel, three skyscrapers named for addresses that range from 1 to 101 on California Street, and a fourth skyscraper named 4 Embarcadero Center. In the foreground is the backside of a 710-ton fountain sculpted by Armand Vaillancourt in 1971. On the night before it was dedicated, he spray-painted it with the words "Québec libre!" In 1987, on the occasion of a free concert by U2, Bono spray-painted it with the words "Rock & Roll stops the traffic." Mayor Dianne Feinstein accused him of vandalism and the police launched an investigation, but Vaillancourt took the position that graffiti are a necessary evil. At a subsequent U2 concert in Oakland, he spray-painted the stage with the words "Stop the madness!" Local citizens have called his fountain "a public fraud" and "a cubist intestine." When Legoland California included a scale model in its San Francisco exhibit, visitors commented that it looked better than the original. Water for the fountain was shut off in 2001, and three years later, a member of the board of supervisors called for its demolition, describing it as "a sheltered public space where the homeless sleep at night." The board voted to turn the water back on.

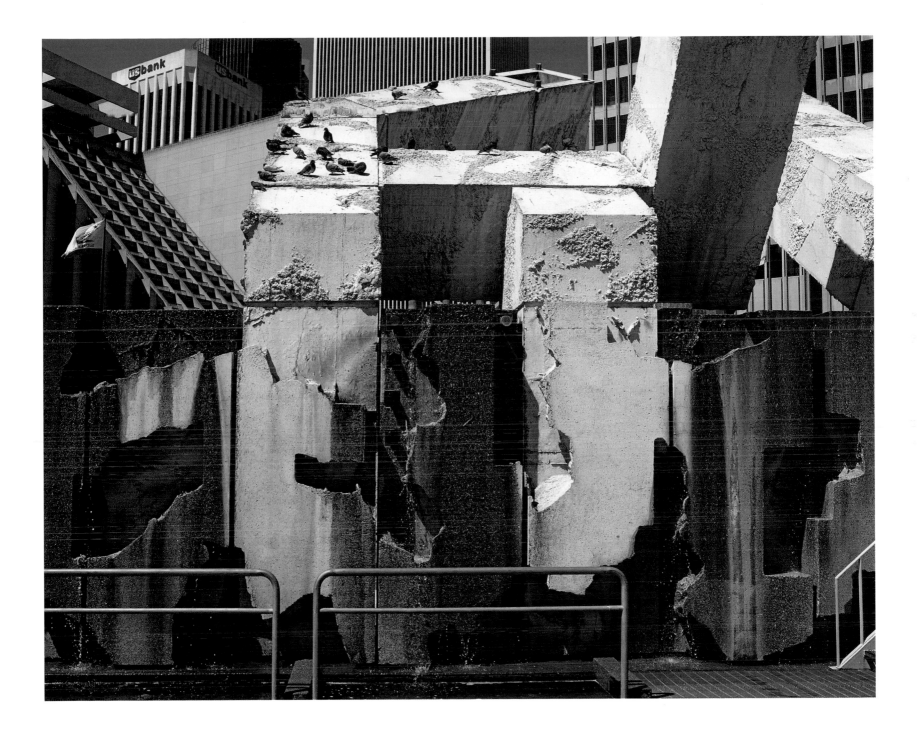

Remnants of the Gothic Revival

On this pair of beauty parlor chairs, Naugahyde upholstery has withstood the weather better than metal tubing. Blocks of white marble bear traces of the mortar that held them together when they formed the twin towers of the new Cathedral of St. Joseph in Buffalo, New York, 40 miles west of this rural junkyard. Completed in 1915, the new cathedral was designed by Aristides Leonori of Rome, the most famous church architect of his day. Like the old cathedral, consecrated in 1855, the new one was Gothic Revival in style, but it was grander, with 260-foot towers, and it stood on higher ground, facing a broad avenue lined with luxury homes. A 45-bell carillon was installed in the towers at the direction of Bishop Charles Henry Colton. He died three weeks before the cathedral was consecrated, and when his bells were rung, their vibrations weakened the masonry. They were taken down and stored, prompting *Ripley's Believe It or Not* to describe the new St. Joseph's as "a cathedral with the belfry in the basement." Bishop Colton was laid to rest in a marble sarcophagus on the Gospel side of the high altar. For the sake of safety, the towers were dismantled in 1928, and their marble parts ended up here. When the rest of the building was demolished in 1978, the bishop's remains were moved to the crypt of the old cathedral, but nearly all the bells had disappeared.

Turbulence House

An alloy of zinc and aluminum coats the 31 steel panels that compose the outer surface of this guest cottage. They were prefabricated in Kansas City by a firm that makes skins for airplanes and then bolted together on top of a mesa near El Rito, New Mexico. Steven Holl was the architect, and his clients were poet Mei-mei Berssenbrugge and artist Richard Tuttle. The poet notes that the architect "filled a small model with gel and shot lasers through it to create computer points for fabricating the panels. It was important to me that the building be prefabricated and available to others, and in fact another Turbulence House was made and exhibited inside a Palladian basilica in Italy." For the architect, the name "Turbulence" evokes a problem in fluid dynamics. He recalls Werner Heisenberg's notion that not even God would be able to answer the question "Why turbulence?" For the artist, the architect's work "just misses functionality as well as art, floating somewhere between, uncomfortable, never quiescent." The house "leaves the ground" because the architect got up at dawn and "circled far and wide to find local cobblestones and completely lined the irregularly cut foundation. So simple, so implicit, so understanding of the beauty and power of those millions-of-years-old rocks, he finished his statement and laid 'Turbulence' to rest." Barely visible at the foot of the wooded hills to the right is the adobe house of the nearest neighbors.

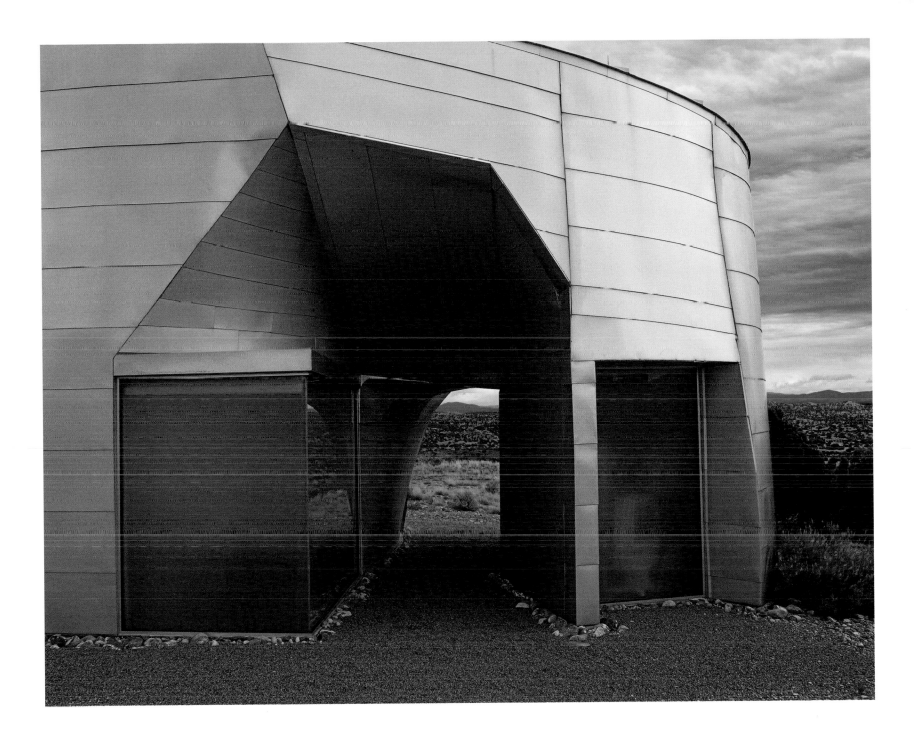

The Color of Earth

On the north side of the chapel of The Immaculate Heart of Mary, the shadow cast by the walls has been getting shorter for three months. At midday, the sun of the spring equinox melts the snow that fell last night. The chapel, facing west, stands at the end of Mt. Carmel Road in Santa Fe. It dates from 1962, but it was built in the image of the adobe mission churches of colonial New Mexico, with flat roofs drained by wooden canals that pierce the parapets, walls with curved edges and gentle outward slopes, blank expanses of earth-colored plaster, wooden lintels supported by Ionic corbels, and paneled wooden doors fitted with cast-iron hardware. But the wood lacks the marks of an adze, and no one has carved and painted the faces of the corbels. The plaster is lime stucco with color added, not earth possessed of its own color. Behind the stucco are courses of concrete blocks, not adobe bricks. Living a cloistered life on the other side of the chapel are nuns of the Discalced Carmelite order, who founded their convent in 1945. They were preceded in their quarters by atomic scientists, who came seeking rest from their wartime duties at Los Alamos. Before that, going back as far as 1902, the residents were patients seeking a high-altitude cure for tuberculosis.

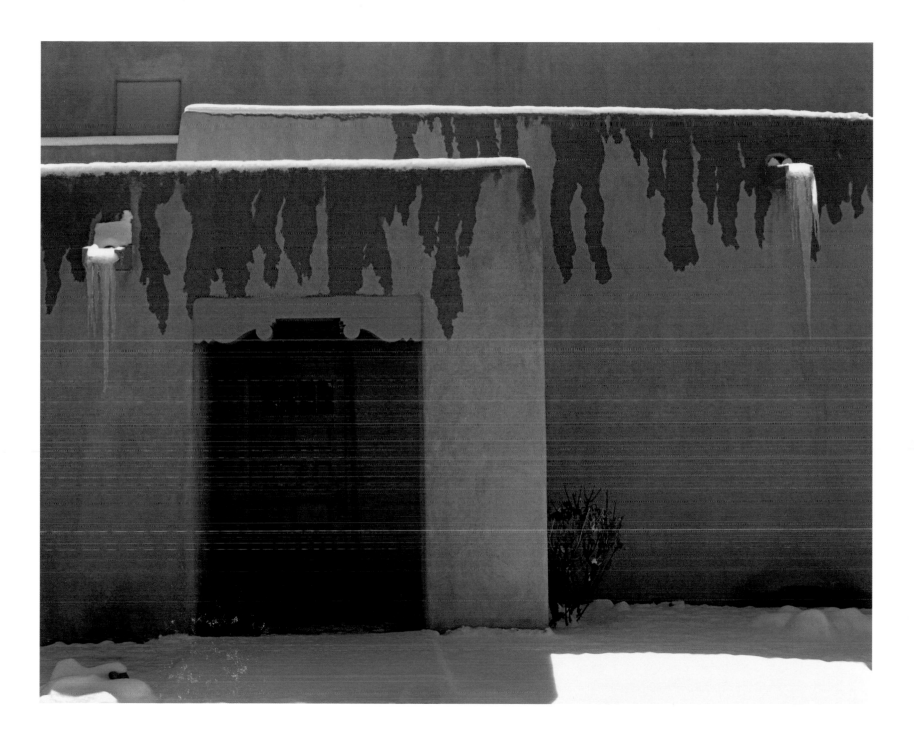

Hidden Entrance

On the last day of 2006, two feet of wet snow have fallen on the ridge that separates the city of Santa Fe from Hidden Valley. There is parking space for two cars in front of the gray wall, but the only tracks are those of a rabbit, emerging from the shelter of the piñon pine at left. Georgia O'Keeffe once painted a wall like this one, with two identical openings, only hers was abode and this one is frame stucco. Her openings were the windows of a house, but she painted them as blank as her wall, giving no clue as to what was inside. Jeff Harnar, the architect who drafted the plans for this house in 1994, has allowed us to see a hillside crowned by a morning cloud, the bare branches of an apricot tree, and a second wall beyond the first one. But he, too, has kept our eyes outside. To arrive at the front door, we would have to go through the right-hand opening and turn right into an alcove. As for the people who live here, there is evidence below the piñon pine at right that they have been shoveling snow, but they must have come out of the house through some other door.

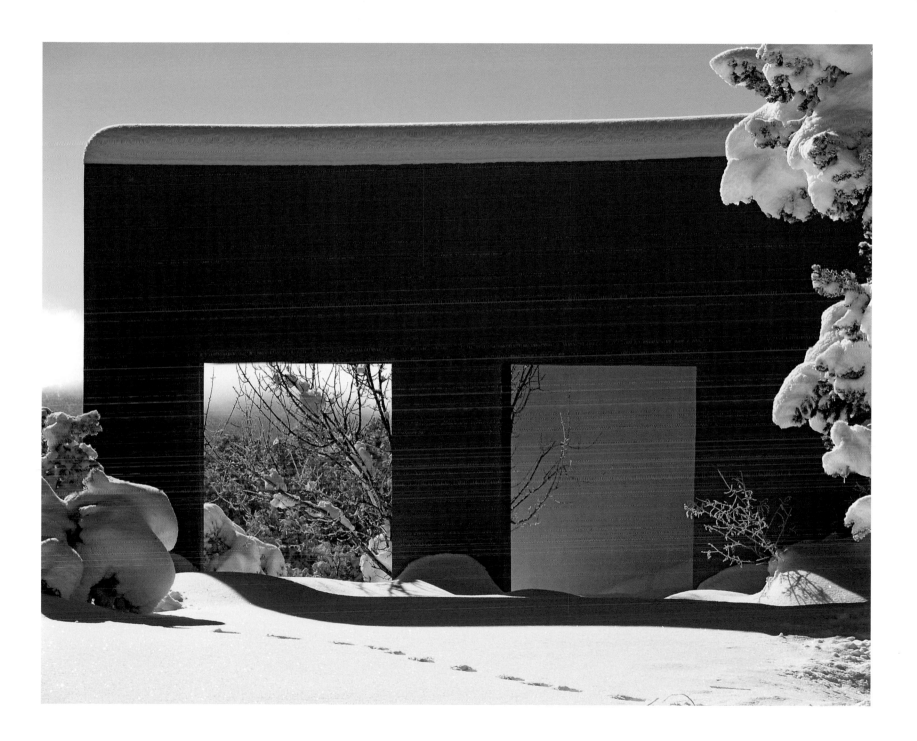

Acknowledgments

The story of my interest in photography begins where my parents began their life together. When E. W. Tedlock Jr. and Agnes Peterson Tedlock came to New Mexico from Missouri, they opened a photography studio in Albuquerque. They closed it after a few years, but they kept the darkroom equipment. Later, when I attended Highland High School in Albuquerque, I used that equipment when I elected to take a photography course from Kenneth Hopperton. He encouraged me to write to photographers whose work I admired, asking questions. The individual who responded most generously was also the most famous: Ansel Adams, who wrote his letters on an electric typewriter with an elegant typeface. Throughout his long career, he was articulate not only when he had his hands on his camera or enlarger, but when he had his hands on a keyboard as well.

Whenever photography returns to the foreground in my work, architecture seems to come with it. While I was studying photography in high school, I was also making drawings of imaginary buildings and plans for imaginary cities and wondering whether I should pursue a career in architecture. Years later, in one of my many conversations with the art critic and bookseller Gus Blaisdell, he showed me the architectural photographs of Lewis Baltz, all in black-and-white, and what he had written about them. He made a passionate argument against color, but all I can say is that I always found disagreements with Gus as instructive and enjoyable as agreements. I remain committed to color.

In recent years at the Santa Fe Photographic Workshops, I have sharpened my skills in digital processing and printing under the tutelage of David Julian and John Paul Caponigro. For nurturing and advancing my thinking about the composition of photographic books, I am

149

grateful to Sam Abell and Leah Bendavid-Val. It was during the workshop they offered that I put my first five text-and-image printouts on display. Thanks also go to John Langmore, a fellow member of the workshop, for his understanding of what I was doing.

While assembling the double-page spreads for this book, I designed and printed a set of broadsides using the same materials. In 2011, the Meridian Gallery in San Francisco featured a show of the broadsides, running concurrently with a show of the architectural sculpture of Richard Berger. For giving me time and space for my work, I thank Anne Trueblood Brodzky, the gallery's director. Always at her side is Anthony Williams, who shares with her the administration of the Society for Art Publications of the Americas, the nonprofit organization that stands behind the gallery. I also thank Jarrett Earnest, formerly a curator at the gallery, for his early interest in my work. For their patient work in mounting the show, I thank Leah Savitsky, Samuel Ezzaher, and Jonathan Nicholson. Among those who came to the opening, Jonathan Fernandez gave me the gift of his amazing insights.

Also in 2011, I published an essay that gives a preview of the present book in the Dutch journal *etnofoor* 23 no. 1: 105–23. I am grateful for the support of the members of the journal's editorial collective, especially Marleen de Witte and Martijn Oosterbaan. For their quick and lively responses to the published essay, I thank Chuck Bigelow, Jean-Guy Goulet, Shannon Lee Dawdy, Ivo Strecker, George Marcus, Jay Edwards, and Sally and Richard Price.

Throughout my work on the book, in New York and New Mexico, I showed samples of the texts and images to friends and colleagues whenever the opportunity arose. For their encouraging responses I thank Harvey Breverman, Sandra Olsen, Yunte Huang, Steve McCaffery, Karen Mac Cormack, Ben Bedard, Arthur Sze, Carol Moldaw, Rikki Ducornet, John Brandi, Renée Gregorio, Sabra Moore, Mei-mei Berssenbrugge, Richard Tuttle, Elizabeth Hadas, Liza Bakewell, and Stryder and Phoenix Simms. Above all I thank Barbara Tedlock, my partner of more than forty years, who casts an equally discerning eye on writing and images.